How to Draw and Paint
Crazy Cartoon Characters

This book is dedicated to my parents,
Shirley and Norman.

How to Draw and Paint
Crazy Cartoon Characters

Vincent Woodcock

A QUARTO BOOK

Copyright © 2007 Quarto Publishing plc

First edition for North America
published in 2007 by
Barron's Educational Series, Inc.

All inquiries should be addressed to:
Barron's Educational Series, Inc.
250 Wireless Boulevard
Hauppauge, NY 11788
http://www.barronseduc.com

Library of Congress Catalog Card No.:
2006920212

ISBN-10: 0-7641-3573-2
ISBN-13: 978-0-7641-3573-6

QUAR. HCD

Conceived, designed, and produced by
Quarto Publishing plc
The Old Brewery
6 Blundell Street
London N7 9BH

Senior Editors Jo Fisher, Liz Dalby
Art Editor Julie Joubinaux
Assistant Art Director Penny Cobb
Copy Editor Sally Maceachern
Designer Tim Pattinson
Picture Researcher Claudia Tate
Proofreader Robert Harries
Indexer Joan Dearnley

Art Director Moira Clinch
Publisher Paul Carslake

Manufactured by Pica Digital Ltd (Singapore).
Printed by Star Standard Industries
(PTE) Ltd (Singapore).

Contents

Characterization

Professional Practices

Foreword

I was 21 years old when I landed my first job in animation. It was at the prestigious Richard Williams Studio in London, England, and I'd been hired as a messenger. I had a two-hour journey each way to and from the studio, the working days were long, the tasks were often menial, lunch was a rarity, and the money was lousy. I loved it!

In between my daily tasks, such as picking up art supplies, punching peg holes into animation paper, or buying lunch for the staff, I would sneak down to the basement, where I was allowed my own light box setup in a tiny, windowless room. There I would try to use the tips and advice I'd pestered out of the animators to animate short sequences that I would shoot on the video line-tester. Not knowing what characters to animate, I'd make up my own, just to have something to draw.

One Friday evening, as I was about to go home, the producer stopped me at the door. He seemed even more frazzled than usual. "I need some character designs for first thing Monday morning. Fancy having a go over the weekend?"

Without hesitation, I replied, "Absolutely!"

This was it. Someone had seen my dazzling potential! I'd been asked to design an animated character. Whoo-hoo!!

That whole weekend I sweated and drew and erased and redrew until I had the best design I was capable of doing.

I felt pretty pleased with myself when I handed them to the producer on Monday morning. He pensively riffled through them without comment. "Aah... Well, erm, okay. I'll put these with the other six designs, get them off to the client, and see what they think."

The *other* six designs? I should have realized that my work was just to make up the numbers and to help cover every angle in winning the pitch. Needless to say, the client went with one of the animator's vastly superior designs.

But I kept at it–always volunteering to make up the numbers with a design, and drawing every chance I had. Some months later, having submitted some ridiculous talking vegetable characters for a commercial, I was working in my basement closet when the producer stuck his head around the corner. "Guess what? The client chose your design–well done."

I felt a great satisfaction at that moment, but an even bigger thrill many weeks later when the animation was completed. Seeing my character walk and talk and live on a screen made something click in my head and I knew this was what I wanted to do.

Since then I've worked on some wonderful productions and had the chance to learn from some very talented artists. And I'm still learning; it never stops. When I began my career in animation, there were very few useful books in print about cartooning in general and none at all about character design. It was my good fortune to have a job at the best animation studio in the UK and to have access to some highly talented (not to mention extremely patient) artists, including Dick Williams himself. In writing this book, I've tried to make it the kind of manual that would have helped me when I was starting out. I've tried to distill everything that I've learned into these pages: all the insights, shortcuts, tricks, tradecraft, and techniques that I know.
The rest is up to you.

Vincent

"Everything you can imagine is real."

Pablo Picasso

If asked to give examples of humorous character design today, we could choose from hundreds of cartoon characters familiar to us from screen, print, and advertising. The popularity of these cartoon animals, people, monsters, aliens, robots, and the like may seem like a modern phenomenon, but artists and storytellers the world over have been creating improbable creatures for millennia.

Introduction

Satire
Although the English satirical illustrator James Gillray might have been puzzled by the term "character design," here he has created a startling and completely imaginary creature to illustrate his satirical point.

We know from surviving frescoes that the ancient Romans enjoyed drawing amusing characters, and Japanese scrolls dating from the 12th century depict various animals comically indulging in very human behavior. But perhaps the earliest imaginary humorous characters were the carved gargoyles that still adorn medieval churches and cathedrals.

Tracing the lineage of humorous illustration takes us through da Vinci, Dürer, and Bosch to the British satirists and caricaturists of the 18th century such as Hogarth, Rowlandson, and Gillray, and into the explosion of late 19th-century humorous magazines. Sir John Tenniel's illustrations for Lewis Carroll's *Alice in Wonderland* vividly depict such unique creations as the White Rabbit, the Cheshire Cat, and the Mad Hatter, while in both *The Wind in the Willows* and the Winnie the Pooh stories E.H. Shepherd brought to life characters such as Toad, Eeyore, and Tigger. In the United States, Thomas Starling Sullivant and A.B. Frost delighted thousands of magazine readers with their beautifully drawn cartoons of accident-prone humans and anthropomorphic animals. The 20th century gave us newspaper strips and comic books populated with wonderful characters

such as Krazy Kat, Popeye, Snoopy, Little Nemo, Asterix, Calvin and Hobbes, Buck Rogers, the Bash Street Kids, and many, many more. But it is animation that has given us the most vivid and enduring comic characters. Think of Mickey Mouse, Bugs Bunny, Yogi Bear, Ren & Stimpy, Buzz Lightyear, Cow and Chicken, Wallace and Gromit, Homer Simpson, Cartman, Daffy Duck, and a thousand others. What all these characters share is not simply a funny face or a comical voice; they are all vivid personalities with

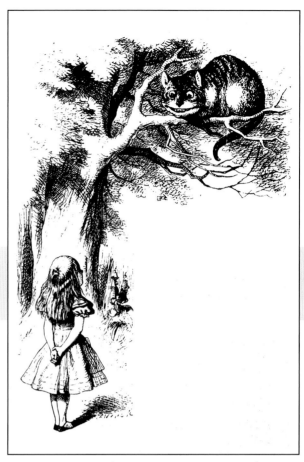

Girl meets cat
In this illustration by John Tenniel, Alice and the Cheshire Cat are clear forerunners of many later cartoon children that interact with strangely humanized animals.

recognizably human strengths and flaws, quirks and foibles. It is personality alone that will make a character transcend the boundaries of its medium to live in our imaginations. This is the job of the character designer.

The requirements of modern advertising and commercial animation production have made the art of character design an increasingly specialized skill. Where once artists created characters solely for their own use, character designers today are often one part of a large commercial process that delivers animated feature films, toys, product logos, greeting cards, comic books, and computer games. Every day we are bombarded with funny characters, and although the vast majority of them are banal, poorly drawn, or derivative, there are still many examples of beautifully realized, genuinely original characters around.

While we must accept the realities of commerce, there is no reason why we artists and designers cannot strive to create unique characters that are imaginative, appealing, truthful, and funny.

It's not a duck, or a sexy girl, or a talking tree that we are drawing—it's personality!

Anthropomorphic animals
Early 20th-century American illustrator Thomas Starling Sullivant was possibly the first artist to depict appealing, anthropomorphized animals with a cartoon sensibility.

Getting Started

This chapter covers the essentials of equipping a home studio space, explores the varying qualities of different drawing and color mediums, and shows how important it is for the aspiring cartoonist to keep a sketchbook and draw daily. The amount of equipment you have at your disposal is not nearly as important as the way that you use it.

Basic Materials

All a character designer needs is a pencil, a stack of paper, and imagination. Ours is a simple art, and a strong concept can be executed with just a few lines on a single sheet of paper.

However, if you are really serious about your craft, there may be times when it is worth investing in some of the items shown over the next few pages. Equipping and stocking your studio space can be expensive, so take things slowly and only spend when the need arises.

Paper

For some design work, such as painting with opaque (gouache) or transparent watercolors, you may need to use more expensive boards and papers, but for everyday sketching and preliminary designs, use the cheapest paper you can buy: typically, photocopy paper. When drawing, the last thing on your mind should be the price of the materials you are using. Worrying about the cost of paper will make you tighten up and be more reluctant to discard a drawing that isn't working. For most color work, I use heavy, smooth drawing paper; it takes both paint and line work (see pages 22-25). If you don't have access to a light box, layout paper is useful for tracing through from a rough when making changes or cleaning up.

Drawing pens

There is a vast range of drawing pens available, so it pays to experiment with various types and makes until you find some that suit your drawing style. If you lay down color with studio markers over line artwork, use water-based inks. Permanent-ink pens are best with watercolor. Chinese-style calligraphy brush pens (with ink cartridges) allow you to produce a brush line without the hassle of using bottles of ink.

Graphite pencils

I prefer a traditional pencil for sketching ideas, although some designers like to use mechanical pencils. In either case, HB or F is the best for most types of character design; a soft pencil produces a strong line without cutting into the paper. For a softer line quality, try china marker pen and charcoal pencils. A pencil-holder is useful for stubs.

Color pencils

Apart from illustration work, color pencils can be useful for preliminary roughing before you clean up in pencil or pen. I like to draw with Col-Erase animation pencils for just this purpose. They're available in a wide array of strong colors, and, unlike most artists' pencils, they're easily erasable.

Pencil sharpener

Electric, battery-powered, or mechanical—the choice is yours.

Erasers

Use art gum for erasing pencil lines on delicate artwork, such as a gouache illustration, and a kneaded eraser for cleaning the paper. A pen-type eraser, its tip cut to an angle with a cutting knife, is great for precision erasing.

Tapes and adhesives

I use low-tack masking tape for positioning rough artwork on a light box, and Magic Tape for securing artwork or reference material (useful when you're photocopying since it doesn't show). Glue sticks are cheap and handy for quick cut-and-paste jobs. Only use expensive spray adhesive for final presentations.

Brushes

Whether you work with inks, watercolor, acrylic, or gouache, you will need good-quality brushes. Sable brushes are superb; they keep their point and can last for years. Buy the best quality you can afford. You won't need that many; a single Winsor & Newton Series 7, no. 1 or 2 sable brush will do for just about any kind of line and wash work.

Drawing aids

Use transparent plastic rulers for straight lines, steel rulers with a cutting knife, T squares for ruling comic panels and parallel lines, and ellipse and circle guides for mechanical detailing and speech balloons.

Dip pens and nibs

Old-fashioned they may be, but for traditional cartooning with a characterful line, dip pens are impossible to beat. They are such good value for money that I would suggest buying a couple of dozen different types and experimenting with them all until you find one that you love using. There are many manufacturers, but both Hunt and Gillott produce top-quality nibs.

Scissors and cutting knives

Use scissors for cutting out reference material, and cutting knives for fine work.

Masking fluid

Use masking fluid to create a waterproof barrier that will protect certain areas of an illustration when you lay down a color wash. Masking fluid should only be used on cold-pressed (shiny-surfaced) board and card because it can tear away the surface of rough-toothed papers.

Mixing trays

Mixing trays are useful but you can use a white ceramic dinner plate instead.

Sponges

Sponges are useful for textured effects.

Studio tips

1 Keeping an old cork on the end of your cutting knife will protect the blade *and* your fingers!

2 Don't cut card or paper using plastic rulers; the blade will ruin the straight edge.

3 Store your soft, kneadable eraser in an old 35mm film canister with a cap. This will stop the eraser from getting grubby and picking up pencil shavings, etc.

4 When drawing straight lines, roll the pencil as it runs along the ruler's edge and the point will stay sharp.

5 Keep scruffy, old, worn-out brushes for applying masking fluid.

6 When making large, long cuts in thin paper, you can avoid a ragged edge if you don't "chop" with the scissors; keep the edges about 1/3 open and you can smoothly scythe through the paper.

7 Can't find that kneadable eraser? Compress a crustless piece of bread into a ball and you have a cheap alternative.

8 After using adhesive tape, fold the end over on itself and it's ready to use the next time.

9 Wooden cutlery trays make handy holders for pencils, pens, etc., and are stackable.

10 Use an old toothbrush for spatter effects.

Color media

Unless you work with cut paper or collage, or you are scanning in your pencil drawings and coloring them using Photoshop, you will need to work with at least one other medium in order to produce color artwork.

Inks
Modern artist's inks come in an incredible array of colors. A transparent medium, they are used to color inked designs.

Acrylic paint
Acrylics are very versatile. Used straight from the tube, they can be blended in much the same way as oil paint, or used to make blocks of flat color. When diluted, they can emulate watercolor.

Studio markers
Studio markers are spirit-based, ink-filled artist's pens that are available in hundreds of shades and hues. Being spirit based, they dry instantly and are, with the exception of pencils, the least messy of all the color media. Long favored by storyboard artists, product designers, layout artists, and character designers, they are speedy, immediate, and an excellent choice for producing color roughs and finished artwork.

Gouache
No other traditional paint can compete with gouache in richness and ease of use. Water-based, gouache paints are practical and versatile, especially for fine work. They are not without drawbacks, however; finished artwork must be handled gingerly and be well protected, as it scratches easily. Gouache is also expensive, and has the nasty habit of drying up in its tube.

Watercolor
Probably the cheapest of all color mediums to invest in, watercolor is also probably the subtlest and hardest to master. It works best when used in transparent glazes, or as a color wash over ink or pencil line art.

Equipment

Items in this list of equipment range from the everyday and essential to the expensive and exotic. In the beginning, borrow what you can and improvise wherever possible. For example, a cheap, secondhand chest of drawers can serve as a plan chest; a bedside cabinet can function as an artist's taboret.

Light box

An animator's light box is best for a character designer. Its drawing angle is adjustable, and it usually has a rotating, transparent drawing surface in the middle, positioned over a backlight. As well as for animating, it is useful for working over roughs, tracing photographs, and so on.

Lighting

Without adequate lighting, both your eyes and your artwork will suffer. Two lights are best—one on each side of your drawing area. If you only have one light, get an adjustable one. Position it a little in front of you on the opposite side of your drawing hand, aiming back down at your artwork. This will ensure that you are not working in your own shadow. Daylight bulbs or fluorescent tubes give a more natural light quality; indispensable for color balance and avoiding eye strain.

Work surface

You can use any table of a practical size and height to draw on. Try to situate your studio area in a well-lit room, away from any direct sunlight.

Chair

Ideally, your chair should be adjustable for height and comfort. You should be able to find a good one in a secondhand office furniture store. It should be neither too high nor too low relative to your worktable. I know many artists who have developed chronic back problems over the years from inadequate seating, so if you have the money, I advise you to invest in a good-quality chair.

Shelves

Useful for reference books, magazines, art equipment, and for displaying your collection of cartoon figures!

Computer

In addition to using a computer as a research tool, you may decide to start producing finished color artwork on it.

Filing cabinet

An easy item to buy secondhand, a filing cabinet can be used to house reference photos and illustrations.

Scanner

If you are using software such as Photoshop to work over pencil drawings, you will need a scanner to upload your preliminary artwork.

Artist's taboret

The artist's taboret has drawers, shelves, and recesses for storing all the materials—such as pens, paints, rulers, and brushes—that you want close at hand. They can be expensive, so try hunting down a cheaper one on the Internet.

Sketchbooks

"Observe everything. Communicate well. Draw, draw, draw."

Frank Thomas, Disney animator.

To be a successful character-designer, illustrator, comic-book artist, or animator, you need to develop ease and fluency in drawing. Developing your skills as a draftsman is much like learning to speak a second language—you have to understand the rules of construction before you can articulate an idea.

Your sketchbook is a private place for learning, making mistakes, observing, and pushing yourself. The more you draw from life, the greater your visual vocabulary becomes and the freer you are to express what you can imagine. Look closely at everything around you and draw it. Remember, the art of drawing is really the art of seeing.

Choosing a sketchbook
Choose a sketchbook that suits the way you like to draw, in terms of size and media.

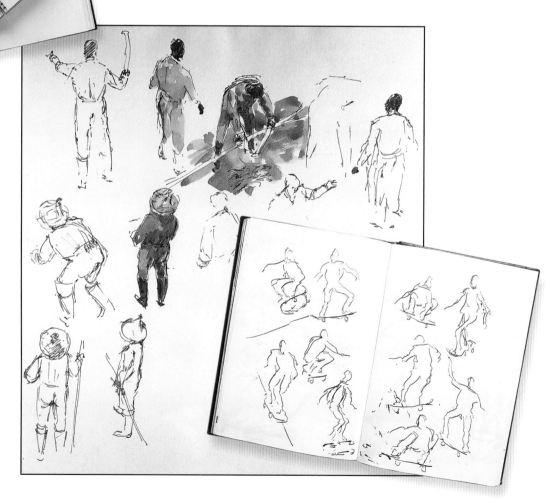

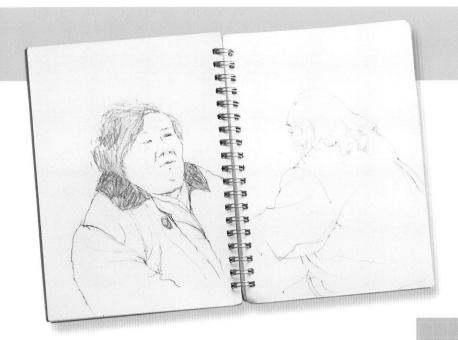

Sketching on location

Draw as much as you can, wherever you can. Give equal attention to posture, gesture, and expression.

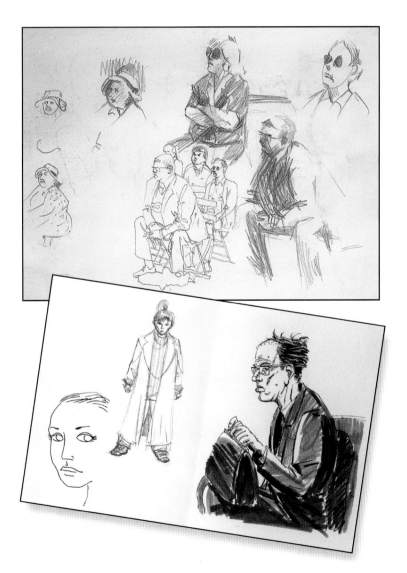

Sketchbook tips

1 Use your sketchbook to experiment with different media.

2 Try to keep your sketchbooks private; worrying about criticism can make you uptight.

3 Get into the habit of taking your sketchbook with you wherever you go.

4 Draw every day.

5 Concentrate on drawing people and animals—your friends, family, pets, strangers—anyone!

6 Use the freeze frame on your DVD player to sketch postures, gestures, and expressions from your television. Remember, creating a memorable character is all about personality!

7 If you get an amusing or interesting idea, quickly jot it down in your sketchbook. You never know when you may need it.

8 Make caricatures of people around you. Don't just make a big nose bigger; try to capture something of its character.

9 A day spent drawing animals at a zoo or park is worth a month of drawing from photographs.

10 Don't be a purist; draw anything you fancy in your sketchbook—portraits, caricatures, cartoons, people, animals, comic strips, flights of fancy—anything!

The humble pencil is a remarkable drawing tool. It is capable of producing an amazing range of marks, from translucent wisps of shading to the heaviest of dark strokes. With its many gradations of gray, the pencil can depict the subtlest interplay between light and shadow, form and void.

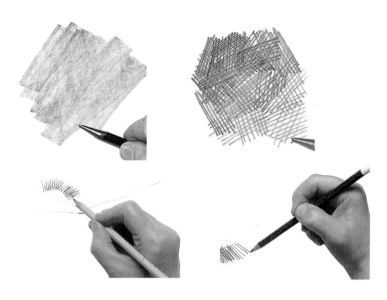

Shading effects
A range of techniques: side strokes with a graphite stick for filling in, cross-hatching, a standard grip for tight control, and a higher hold for a looser feel.

Mark-making: Pencil

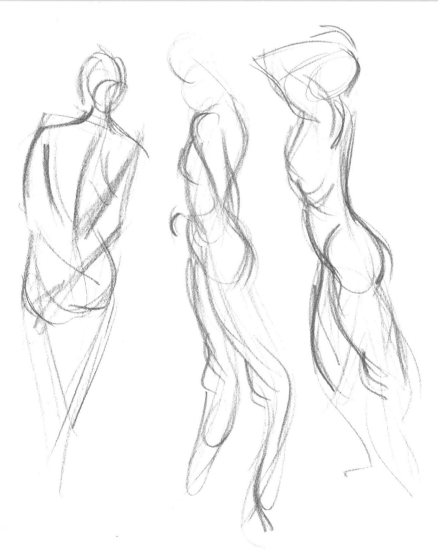

When you draw with a pencil, try to vary the marks you make. You can draw with a sharp tip, or a blunt one, or even with the side. Study the drawings of artists you admire and copy the way they made their marks. Get to know the pencil's advantages and limitations, and keep drawing until it feels like an extension of your hand. Keep experimenting, and never be afraid of making mistakes. Drawing may be "taking a line for a walk," as the artist Paul Klee once remarked, but that doesn't mean that you should take the same path every day.

Volume
Use both the point and the side of the pencil in combination to define shape and suggest volume.

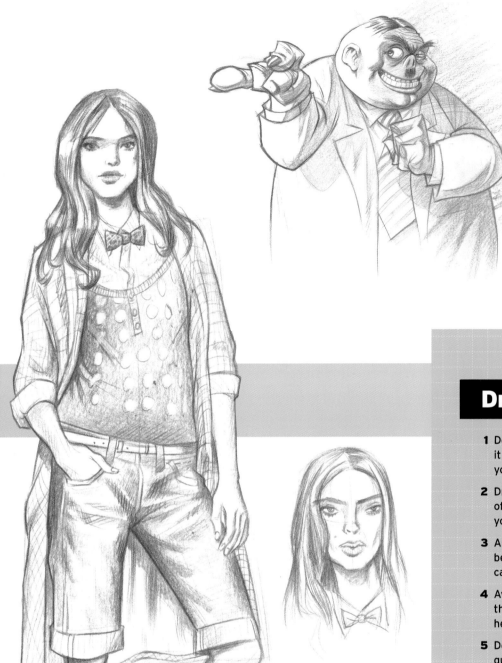

Variation
When drawing from your imagination, keep the design interesting by varying the way you make your pencil marks. Always try to find the contrast in a drawing; light with dark, sharp with round, and so on.

Drawing tips

1 Don't grasp the pencil too firmly; it should feel light and responsive in your hand.

2 Draw with different grades and brands of pencils until you find some that you like.

3 As a general rule, a softer pencil is better for quick sketching, as it is capable of more tonal variety.

4 Avoid erasing "incorrect" lines; leaving them in lets your drawing breathe and helps you learn by your mistakes.

5 Don't be too concerned with line quality—it's more important to think about the volumes you are drawing than their edges.

6 Set yourself challenges in your drawing. Carefully study a face, for example, and then try to draw it from memory.

7 Vary your approach. If you spend an hour on a single drawing, follow it up with a series of very quick sketches.

8 When drawing faces, pay particular attention to expression in the features.

9 Don't labor a drawing—if you've lost interest in it, or it's not working, stop and move on.

10 Even with the simplest and most graphic drawings, think in three dimensions.

Formal drawings
Making more formal drawings from photographs in books or magazines will help you to use the pencil with control and finesse. As you draw, try to analyze the mechanics of the posture for future use in your own designs. For example, in this drawing, the girl's weight is supported on her right leg, allowing the hips to tilt to the left and her left leg to be bent.

Drawing in ink has long been a favored technique for illustrators. The high-contrast, black-and-white clarity of an ink drawing makes it particularly suitable for reproduction in print. Although there are digital alternatives, if you are starting to create characters for your own comic strips or story illustrations, it is worth getting to grips with using ink because of the inherent "organic" qualities of the medium.

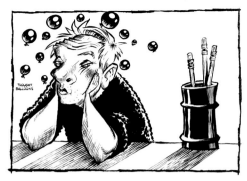

Brush and ink
This comic panel was drawn using only a no. 2 sable brush. Used deftly and imaginatively, a brush is capable of an enormous range of textures and effects.

Mark-making: Ink

Traditionally, comic artists worked in brush or pen—or occasionally a combination of the two. Today, there are a number of alternatives to a dip pen and brush. Manufacturers offer hundreds of different drawing and calligraphy pens; it's up to you to find something that you enjoy using.

Dip pen
Here a traditional dip pen is used to produce a number of different strokes and textures. A flexible nib is particularly good for feathered strokes. But beware! Dip-pen inking can be tricky; notice how some of the cross-hatching has filled in because some of the strokes weren't dry.

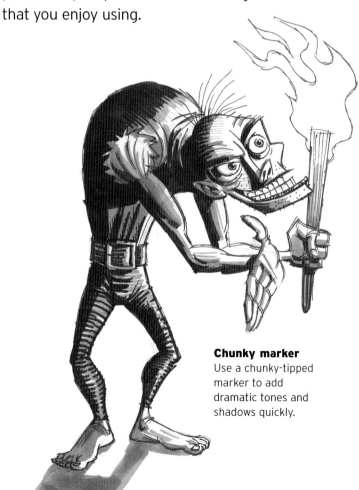

Fiber tip or ballpoint pen
Here a 0.5 drawing pen is used to produce a quick sketch. What this type of pen lacks in stroke variation, it makes up for with ease of use.

Chunky marker
Use a chunky-tipped marker to add dramatic tones and shadows quickly.

Chunky brush lines

Tonal effects drawn by pen

Brush and pen

These two illustrations show different shading techniques. The brush gives a feathered stroke and a chunkier line of varying weight and starkly contrasted borders between black and white. The pen produces gray tones using parallel or cross-hatched lines. Use a brush for punchy contrast, and a pen for delineated shapes carried more by tone than outline.

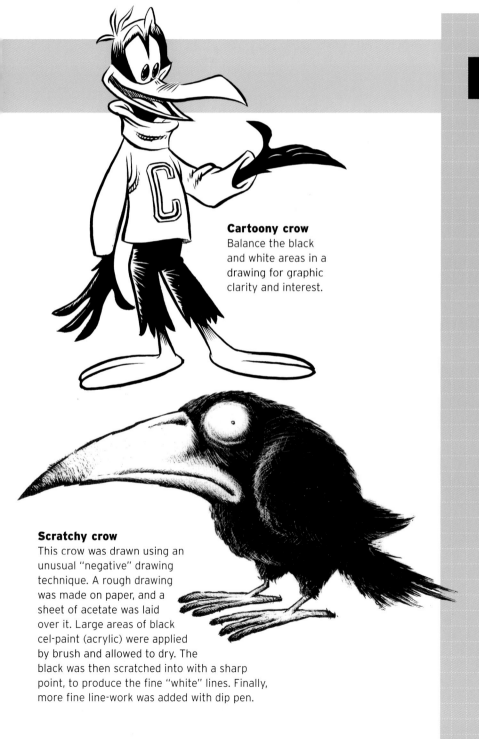

Cartoony crow
Balance the black and white areas in a drawing for graphic clarity and interest.

Scratchy crow
This crow was drawn using an unusual "negative" drawing technique. A rough drawing was made on paper, and a sheet of acetate was laid over it. Large areas of black cel-paint (acrylic) were applied by brush and allowed to dry. The black was then scratched into with a sharp point, to produce the fine "white" lines. Finally, more fine line-work was added with dip pen.

Inking tips

1 If you're inking with a pen and require a precise line quality, it's best to use a hard surface paper such as illustration board.

2 Despite manufacturers' claims that their inks are waterproof, in reality some are not. If you plan to add watercolor to your pen drawing, it pays to do a test first.

3 When inking large areas, such as a comic page, ink from the top on the opposite side to your drawing hand and work your way down, turning the artwork when necessary.

4 Put a little talcum powder on the underside of your drawing hand so that it doesn't stick on the drawing surface.

5 When inking comic strips, keep your technique consistent. For example, if you stipple your shadow areas, don't suddenly switch to cross-hatching.

6 Feather the excess ink from a charged pen or brush on a piece of scrap paper to avoid blobbing on your artwork.

7 To make a holder for your ink bottle, use a piece of heavy card about 6 in. (15 cm) square. Place your ink bottle in the middle and draw around the base. Make four cuts with a blade from edge to edge across the center until you have eight equal-sized sectors. Open these like the petals on a flower and push the card over the bottle until it's level with the bottom. Your bottle of ink is now next to impossible to knock over.

8 To make your black drawing ink blacker, take the lid off for a few days and let some of the water content evaporate.

> **"You arrive before nature with (color) theories and nature throws them to the ground."**
>
> *Pierre-Auguste Renoir*

Adding color to your artwork will bring characters more fully to life and allows you to infuse them with extra layers of interest. Color choices can be as natural or as quirky as you wish, but should always be considered in context—an outfit of purple and green may look great on a super-villain, but less so on a baby. (Unless it's a baby super-villain, of course!)

Mark-making: Color

There are many ways to bring color to your characters, and each requires a different technique. In addition, you must develop your own color sense, your own sense of chromatic balance. Color is all about juxtaposition. Keep experimenting until you have an intuitive feel for which colors work well together in the context of the characters you are designing. There are no hard and fast rules with color; if it works, it works.

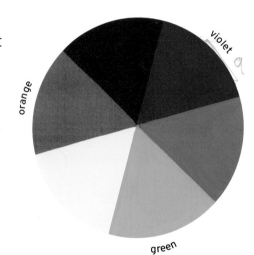

Secondary colors
Any two of the primary colors can be mixed together to produce a secondary color.
• Red + blue = violet.
• Blue + yellow = green.
• Yellow + red = orange.
The exact shade of secondary color produced depends on the hue of the primary color.

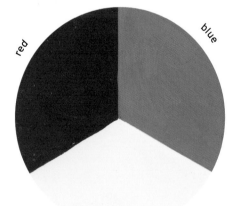

Primary colors
There are three primary colors: red, blue, and yellow. They are called primary colors because they cannot be made by mixing any other colors together.

Choosing a color palette

Using a knowledge of color mixing will enable you to make more informed color choices, as well as sidestepping the need for dozens of tubes of paint; you can always mix the exact color required from, say, 12 tubes of paint (four different shades of each of the primaries). However, it's nearly impossible to mix up really zingy greens, purples, mauves, and pinks, so it's worth buying these in addition to primaries, plus black and white, of course.

Complementary and tertiary colors

Complementary colors are two colors that will increase in intensity or brightness when placed next to each other. The complementary color to a primary color is the mix of the other two primaries. The complementary of red is green, for example.

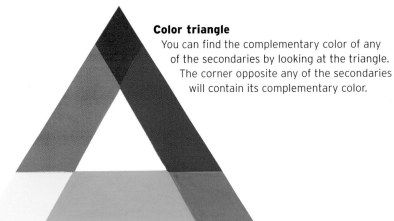

Color triangle
You can find the complementary color of any of the secondaries by looking at the triangle. The corner opposite any of the secondaries will contain its complementary color.

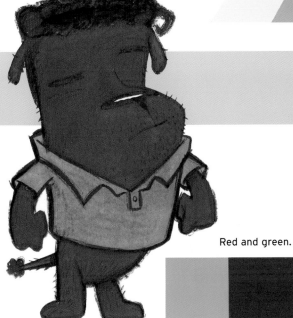

Red and green.

Character colors
Many of the most memorable characters have been designed with just two dominant colors—Spiderman (red and blue); Fred Flintstone (black and orange); the Flash (red and yellow). Here, these characters have been color-keyed around two complementary colors, which adds a little pep to the designs. Mixing two complementary colors together will produce a tertiary color, which will be a shade of brown.

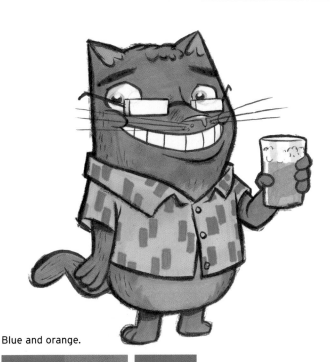

Blue and orange.

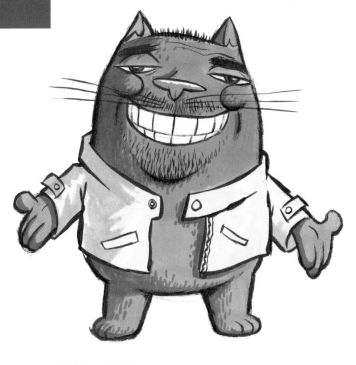

Violet and yellow.

Watercolor washes

Although watercolor is probably the easiest painting medium to get started in, it is also one of the hardest to master. Don't be too worried about that, however; just getting used to laying washes of color over line artwork is enough for now. Watercolor is a transparent medium, so the most important thing to remember is that the lightest point on any painting is the white of the paper itself. Try to plan ahead with your highlights. In this series of color sketches, you can see how the successive layers of wash build up the intensity of the color.

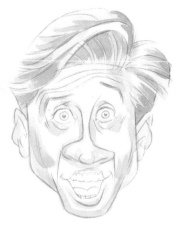

1 The initial pencil drawing was photocopied onto a medium-thick card, giving a stronger, blacker line. The toner will resist thin washes, keeping the line density.

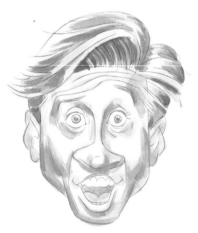

2 Successive layers of wash are laid down with the aim of bringing out the contrasts of the face: light/dark; round/straight; warm/cold and so on.

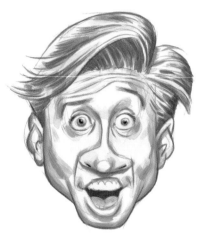

3 After the watercolor is completed, a little pencil rendering is added for a more rounded effect. Be wary of overdoing the shading; you want the finished design to be about character not technique.

Wash

Flat color

Sponged texture

Dry-brush

Creating monochrome textures

When working in monochrome, it is useful to explore working with different painted textures to describe actual texture. For example, dry-brush can be used to indicate fur; apply with long strokes in the direction of the fur.

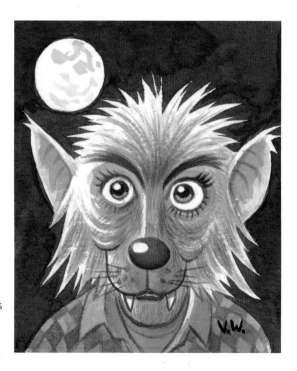

Range of grays

Black Chinese ink, when diluted, gives an almost infinite range of grays. Here, successive washes over a pale pencil drawing have been used to create this friendly werewolf. The use of an outline was made unnecessary, simply by the use of strong contrast between character and background.

Basic technique: gouache

Like watercolor, gouache is a water-soluble medium. Unlike watercolor, however, gouache is bound with glue, giving it a thicker, paste-like texture. Gouache is also already mixed with white, which makes the colors more opaque. The range of colors is greater than regular watercolor, and has more richness when applied as a flat coat. Gouache is a very versatile paint, as can be seen in these examples.

A Masking fluid is applied over the character drawing.

B A pale yellow wash is painted in the spotlight area. The masking rubber is peeled away.

C The masking rubber is peeled away and the character is painted in flat colors.

D Shadow tones are painted over the character to emphasize form.

E Dark blue pencil is applied at the shadows upper edges to heighten the chiaroscuro.

F The character's outline is "inked" in jet black paint using a No. 1 sable brush. The edge of the light beam is drybrushed to soften the transition to black.

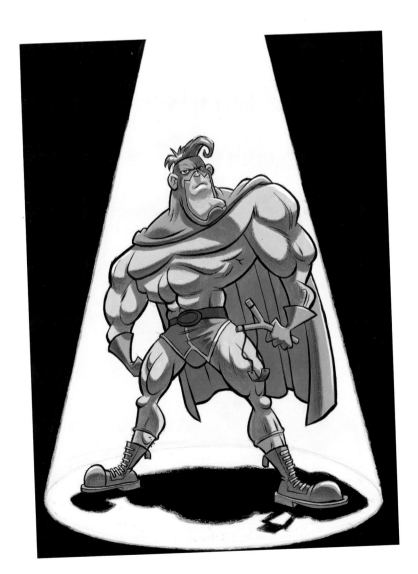

Strong elements
A stable triangular composition and a very simple color scheme, combined with bold tonal contrast, produce a strong, punchy illustration.

Markers

The villainous character on the left was sketched with little detail using an HB pencil. The image was then photocopied and enlarged (about 20%) giving a bold outline. Studio markers were used for the color. A bottom light source was implied to increase the creepiness of the figure. Working with markers is extremely fast and very suitable for storyboard work as well as rough designs.

Trying out colors

In the illustration below, the original pencil drawing was photocopied twice; once at the same size onto 115 lb Bristol board (for the finished artwork), and once at a reduced size onto regular paper (to work out color ideas). Shadow tones were lightly sketched in onto the board in pale blue pencil before any paint was applied. Soft colored pencil work was applied over the finished gouache painting (such as the wood grain).

Opaque qualities

Cartoonists and character designers love gouache because of its remarkable opaque qualities.

Painting

After an initial pencil drawing, the tiles were blocked in with green gouache and the showerhead in a flat gray. A thin side shadow was added in blue pencil. The figure was painted in three flat areas of flesh tones. Soft white crayon was loosely applied for the steam, and opaque white was used in directional strokes for the water, and then dry-brushed on the shoulders.

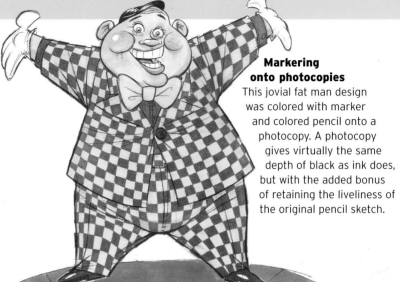

Markering onto photocopies

This jovial fat man design was colored with marker and colored pencil onto a photocopy. A photocopy gives virtually the same depth of black as ink does, but with the added bonus of retaining the liveliness of the original pencil sketch.

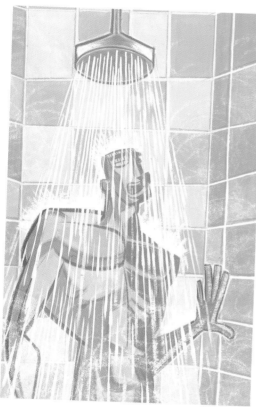

Vivid color

The beauty of gouache is that the colors are bright and punchy. Dry brush technique is used here, with details added in pencil.

Painting and color tips

1. You can erase pencil lines under a blue or red watercolor wash, but not under a yellow wash.

2. Make a swatch of all your paint colors, and keep it with the paints.

3. Don't use masking fluid with a good brush; it'll ruin it.

4. If you want an "ink" outline on your painted characters, dilute black gouache and use it as ink.

5. Keep examples of the work of artists whom you admire in your work area: postcards, magazine clippings, and so on.

6. To use a dry-brush technique, apply the paint to a clean brush and make marks on a scrap of paper until the paint is almost played out; it's now ready to dry brush.

7. Add white to gouache colors to make them opaque.

8. Green gouache is less opaque than other colors and will probably need more than one coat to achieve a streakless density.

9. Always carefully clean and dry your brushes after use, especially when using acrylics; the paint will destroy the hairs.

10. Use the softest of kneadable erasers for removing lines from a finished gouache painting, because the paint surface is very delicate.

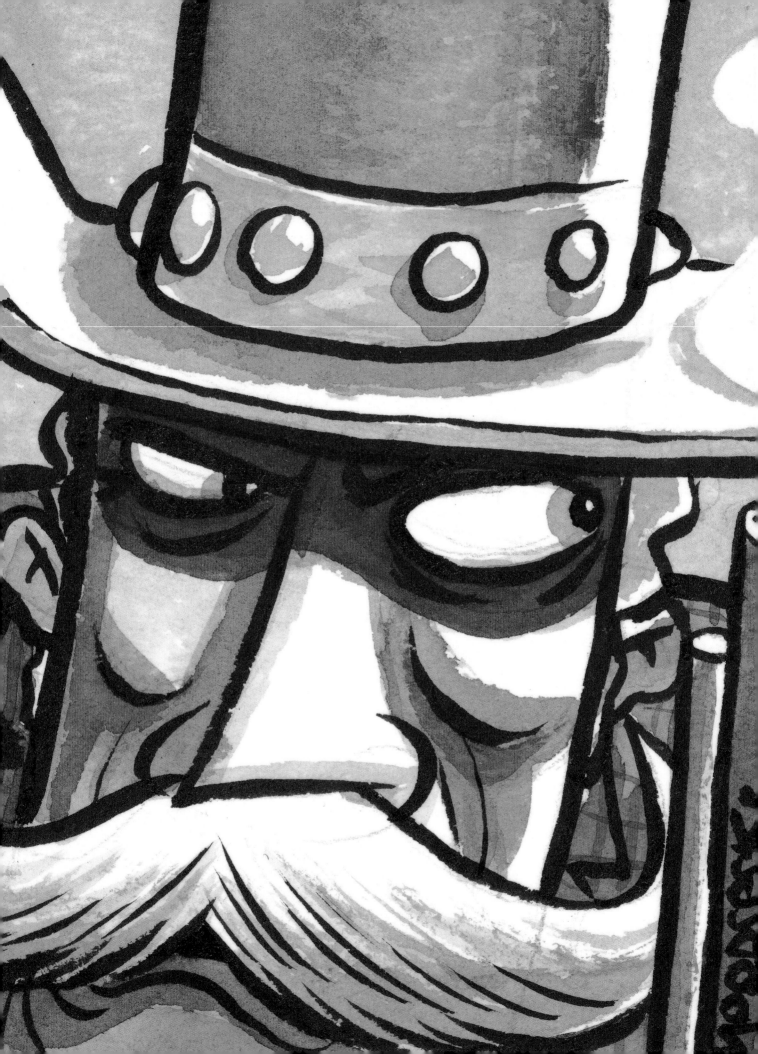

chapter 2

Fundamentals of Drawing

Before you can unleash your imagination and allow it to run wild exploring the countless possibilities for your character's appearance, you must know how to construct characters convincingly and solidly. Learning how the human body works will enable you to pose your characters in a way that makes their postures and their actions plausible. Even the flattest, most graphic character should have a connection to real life; otherwise you are just designing pretty shapes and symbols instead of characters with life and vitality.

Anatomy

The average adult human body is around eight heads high. Children are born with larger heads relative to the rest of their body, but that ratio diminishes as they grow older—from around three heads high at birth to the adult average. The process reverses as the body ages, and people appear to grow shorter (due to curvature of the spine and a more bent-leg posture). It is unusual to see sprightly elderly people, but not impossible.

Heads

When designing human-scale, use the head-height to determine the proportions. The fewer the heads, the more child-like in appearance your character will be. The trade-off is between "cuteness/appeal" at one end of the scale and "power/presence" at the other.

Gender differences

The proportions for women are a little different from men; their legs are longer relative to their height and so their torsos appear shorter. Female necks are not longer than men's; it just looks that way because the female trapezius muscle is less bulky than a man's.

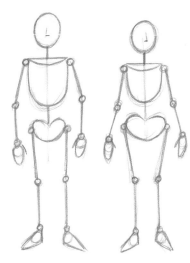

Men vs women
Note how the proportions of the female figure differ from the male in several important ways. The upper body is shorter. The pelvis is wider, which makes the angle of the thigh bone (femur) to the knee joint more acute. This has the effect of throwing out the lower leg in a running action.

Quarters

Using heads as a measure for height is quick and useful, but there is another way of dividing up the body. The halfway point is at the hips, the bottom of the shoulder muscle divides the upper half, and the knee divides the bottom. Again, this gives average human proportions.

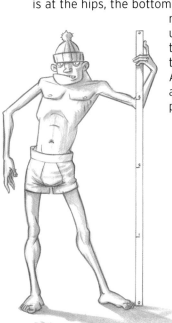

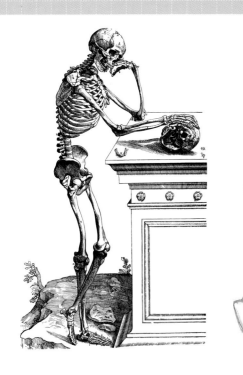

The skeleton

The human skeleton is the supporting structure of the body. It is articulated by the musculature, which is controlled by the brain via the central nervous system. There are around 205 bones in the body, depending on how many have fused together by adulthood. While a thorough knowledge of human anatomy is essential for any serious artist and should remain your ultimate goal, at this stage you just need to understand the body's articulation points so that your characters' poses and postures seem plausible, even when they are wildly exaggerated.

Cute characters

Traditionally, "cute" cartoon characters have a similar head:body ratio to young children. This is no coincidence—cartoonists have always instinctively understood that people are hardwired to respond sympathetically to toddlers, and so they borrow a little of this response for their cute cartoon characters.

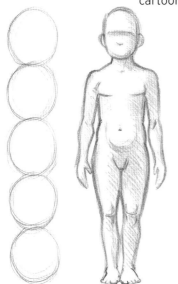

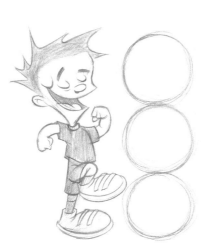

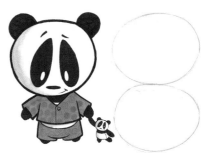

Poses

Practice posing out actions with your articulated figure, paying particular attention to weight distribution. Remember, the articulated stick figure is not a replacement for sound anatomical knowledge; it's just a convenient shorthand device that lets you pose out actions and acting attitudes quickly and dynamically.

Action

When drawing stick figures, decide what they are doing before you start and create a line of action for that pose. This will give dynamism and life to a design.

Create a line of action when a character is throwing a ball...

...or diving into a pool...

...or even just slouching against a wall.

Drawing tips

1 Keep the lengths of the limbs consistent.

2 Vary the proportions and attitudes of your figures, e.g. tall, short, young, old, happy, depressed, etc.

3 Try to make the poses as strong as possible. The key word is exaggeration.

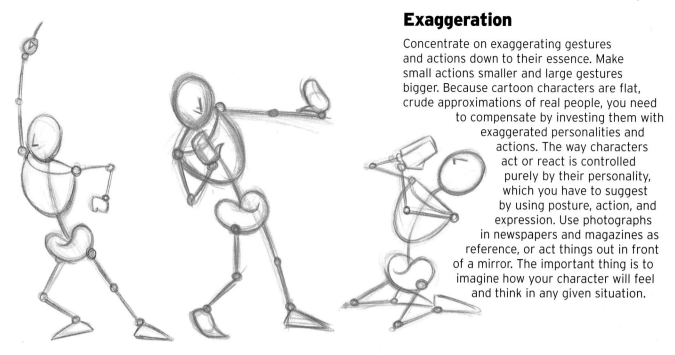

Exaggeration

Concentrate on exaggerating gestures and actions down to their essence. Make small actions smaller and large gestures bigger. Because cartoon characters are flat, crude approximations of real people, you need to compensate by investing them with exaggerated personalities and actions. The way characters act or react is controlled purely by their personality, which you have to suggest by using posture, action, and expression. Use photographs in newspapers and magazines as reference, or act things out in front of a mirror. The important thing is to imagine how your character will feel and think in any given situation.

Construction

The articulated stick figure, although useful for posing, is only the first stage of building a character. You have to flesh out your characters, giving them form, volume, and weight

In the 1930s a technique known as "rubber-hose" developed. Today, it's simply called "traditional cartoon." In this style characters are drawn using as many round shapes as possible. Only cursory attention is paid to anatomical fidelity, and the resulting characters have a bendy, squishy quality to them as if they'd been fabricated from some kind of infinitely flexible rubber. Animation writer and critic Joe Adamson named this nonexistent material "Averex," in tribute to the anatomical distortions created by Tex Avery.

Line
The round shapes of the body and "rubber-hose" limbs are drawn.

Adding tone
This cat has the easy-to-animate, loose-limbed gangliness typical of 1920s designs.

The great teacher of artistic anatomy, George Bridgman, developed an approach to drawing the human body that he called "Constructive Anatomy." He suggested that the body could be seen as a series of interlocking blocks or volumes. This approach can certainly be applied to character design and is very useful for the student who has yet to master human anatomy.

Take some time to practice drawing the basic building blocks shown below. The key is always to imagine them as three-dimensional volumes in space, because even a simple cartoon character, drawn without shading, should have mass, presence, and weight on the paper.

The Building Blocks

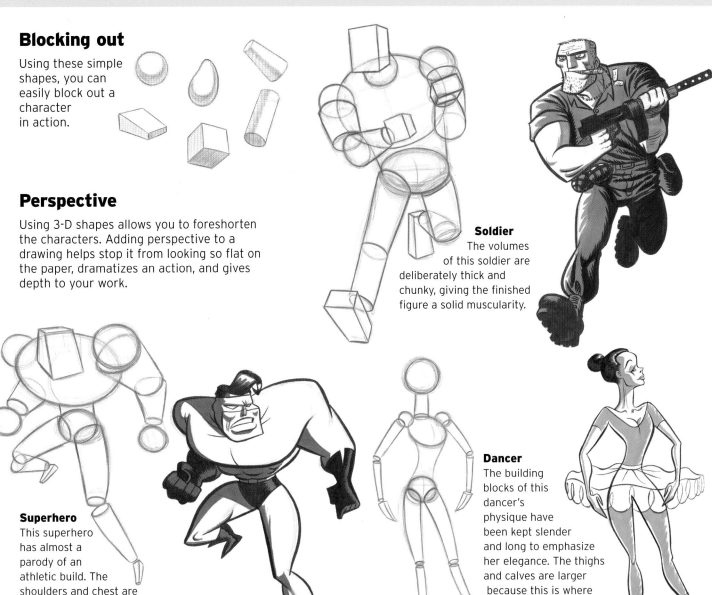

Blocking out

Using these simple shapes, you can easily block out a character in action.

Perspective

Using 3-D shapes allows you to foreshorten the characters. Adding perspective to a drawing helps stop it from looking so flat on the paper, dramatizes an action, and gives depth to your work.

Soldier
The volumes of this soldier are deliberately thick and chunky, giving the finished figure a solid muscularity.

Superhero
This superhero has almost a parody of an athletic build. The shoulders and chest are completely out of proportion to the lower half of his body—a common feature of the superheroic form.

Dancer
The building blocks of this dancer's physique have been kept slender and long to emphasize her elegance. The thighs and calves are larger because this is where a dancer's athletic power to leap comes from.

Posing
A series of basic shapes indicate the dynamics of the finished pose.

Adding life

One major flaw with the building-block approach is that the figure may look lifeless and leaden. The forms may be rounded and have 3-D clarity, but they have lost some of the spontaneity, some of the life that is essential to an appealing character design. A character design is successful if the viewer engages with it on an emotional as well as a visual level. You can create a pose or an attitude very quickly by using the stick-figure technique and then fleshing out the figures with the building blocks.

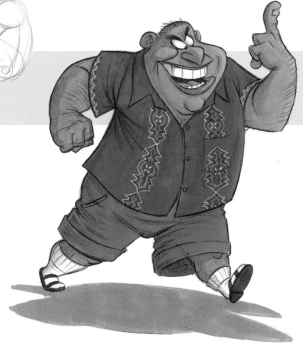

Fleshing out
This shows the form and volume behind the finished character.

Final artwork
A fully realized character.

Looseness

Once you have come to grips with both these techniques, concentrate on achieving looseness in your drawing. Your pencil marks should be light and free—and yet targeted to depicting the mental image and emotion that you are trying to portray. The more you can identify with your characters in your mind, the easier they will be to draw. In time, your construction will become more gestural and less self-conscious. These approaches to construction are not ends in themselves, but simply the means to achieve a creative fluency that is grounded in solid draftsmanship. As you progress, you will find that the construction process becomes less stated on the paper and more intuitive.

These characters share certain basic characteristics: a pear-shaped body, a spherical head, and rubbery limbs.

Hands

Without a doubt, hands can be incredibly difficult to draw. One reason for this is their sheer complexity; over half the number of bones in the human body are in the hands and feet.

The old saying "I know it like the back of my own hand" would prove to be totally untrue if the average person saying it were asked to draw their hand from memory. Although you look at your own or other people's hands hundreds of times every day, how often do you consciously study them? As with anything else, you need to know 'em to draw 'em.

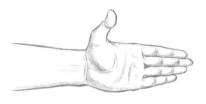

Wrist
The wrist is usually twice as wide as it is thick, and there is a distinctive step down as it joins the hand.

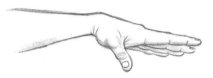

Middle finger
In the average hand, the middle finger is straight and the other fingers curve into it. When the fingers flex, the middle finger, being the strongest digit, is usually the first to move.

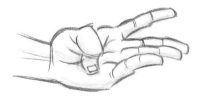

Thumb
The thumb will usually flex inward in the direction of the base of the little finger.

Bones
Here are the bones of the forearm and hand.

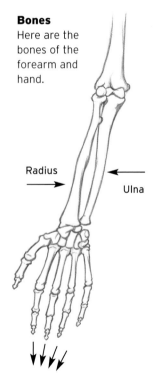

Radius

Ulna

Rotation
The bones of the forearm are included because it's important to see that the hand doesn't rotate at the wrist; the movement originates at the elbow as the ulna and radius bones cross.

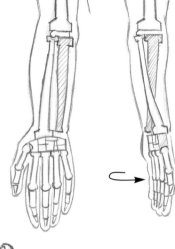

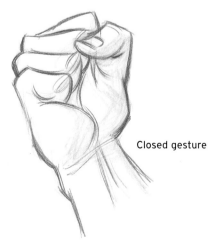

Closed gesture

Conveying emotion

In general, an open hand gesture reflects a positive emotional state, while a closed one shows the opposite.

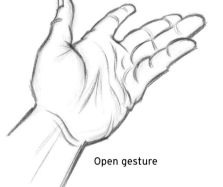

Open gesture

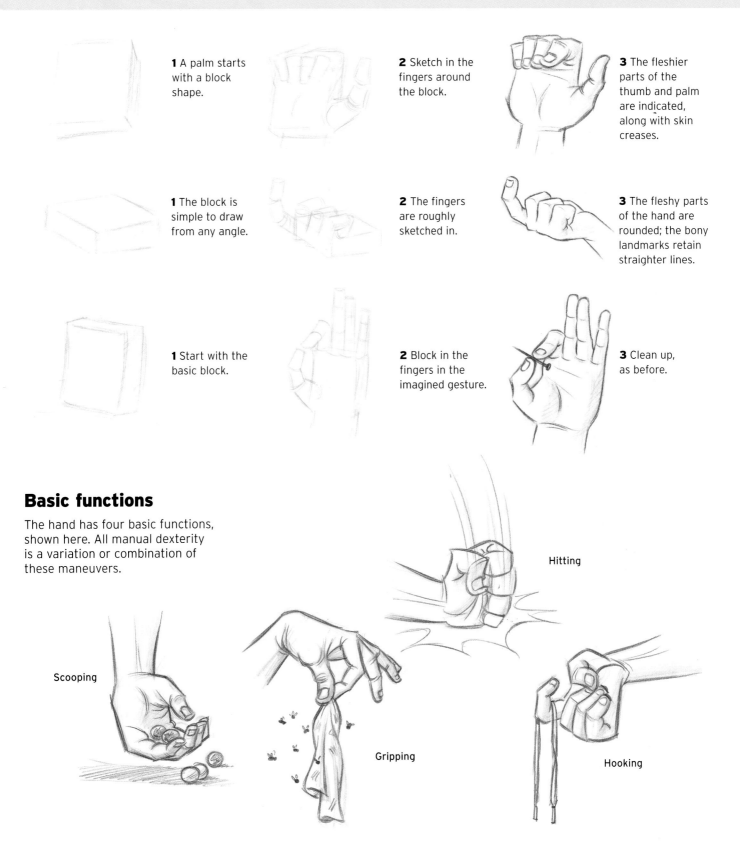

1 A palm starts with a block shape.

2 Sketch in the fingers around the block.

3 The fleshier parts of the thumb and palm are indicated, along with skin creases.

1 The block is simple to draw from any angle.

2 The fingers are roughly sketched in.

3 The fleshy parts of the hand are rounded; the bony landmarks retain straighter lines.

1 Start with the basic block.

2 Block in the fingers in the imagined gesture.

3 Clean up, as before.

Basic functions

The hand has four basic functions, shown here. All manual dexterity is a variation or combination of these maneuvers.

Scooping

Gripping

Hitting

Hooking

Developing a style

Stylistically, there are many possible avenues to go down while still drawing in a cartoon style. You may choose to have just three fingers on a hand— or six! You may leave out one set of joints on the fingers, choose to emphasize the bones, simplify the hand into a starfish shape, or even draw the fingers as if they're made from rubber or chiseled from rock. As long as they are identifiable as hands and can function as you need them to, then their job is done.

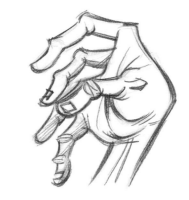

The bones can be emphasized.

A hand may be drawn with flattened fingers.

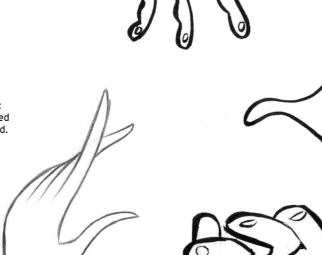

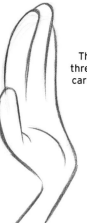

The classic three-fingered cartoon hand.

It can be expressed as a simple outline.

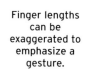

Finger lengths can be exaggerated to emphasize a gesture.

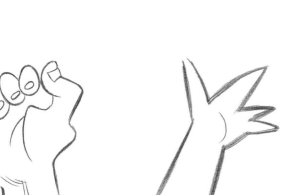

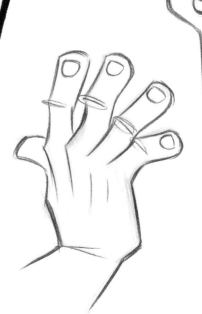

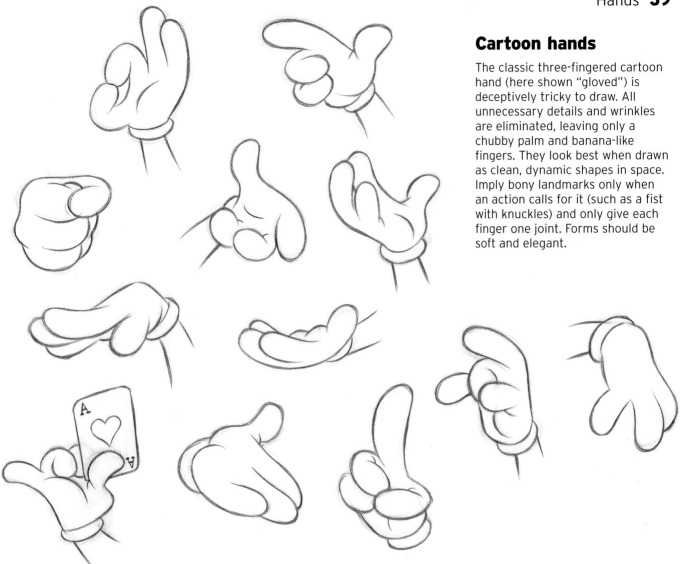

Cartoon hands

The classic three-fingered cartoon hand (here shown "gloved") is deceptively tricky to draw. All unnecessary details and wrinkles are eliminated, leaving only a chubby palm and banana-like fingers. They look best when drawn as clean, dynamic shapes in space. Imply bony landmarks only when an action calls for it (such as a fist with knuckles) and only give each finger one joint. Forms should be soft and elegant.

Gestures

The hand is capable of an enormous range of gestural movement, some of which is deliberate, but much of which is unconscious. Although people learn how to hide their emotions by controlling their facial expressions, the hands often reveal these hidden states of nervousness, discomfort, or pleasure. Practice drawing hands from life, and then simplify them or exaggerate them. Exaggerate the essence of a hand gesture in as few lines as possible. A line should inform the viewer, not clutter the drawing.

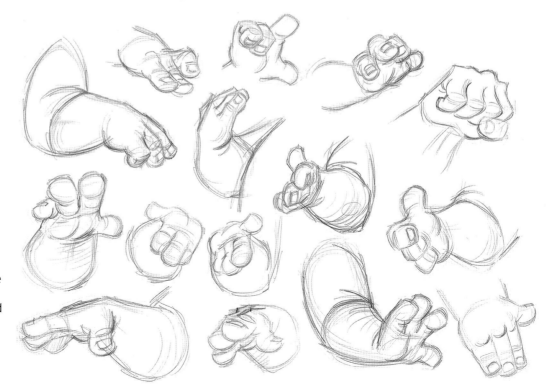

Perspective enables you to draw objects as if they are three-dimensional and occupy a three-dimensional space. Judicious use of perspective in a character drawing will give it volume, depth, and solidity.

A sheet of paper is just a flat surface on which you make marks, but if you engage your imagination, it can be a window through which you look into a 3-D world. The amount of perspective you put into a design varies according to stylistic taste and approach, but it is an essential tool to keep at hand.

Foreshortening characters can "push" them toward the viewer, giving them 3-D solidity.

Perspective

Viewpoint

The way that an object appears to recede away from you depends on your viewpoint.

This represents your paper "window." The straight horizon line represents the viewer's line of sight.

If you view an oblong with its side facing you, it will recede away to a single vanishing point (v.p.). This is called "one-point perspective."

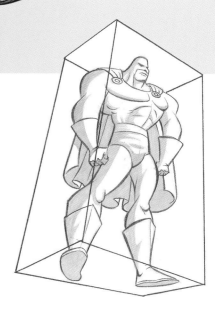

Unusual viewpoint
Applying perspective to characters can be tricky from an unusual viewpoint. Constructing them in a box makes it easier to apply the rules of perspective.

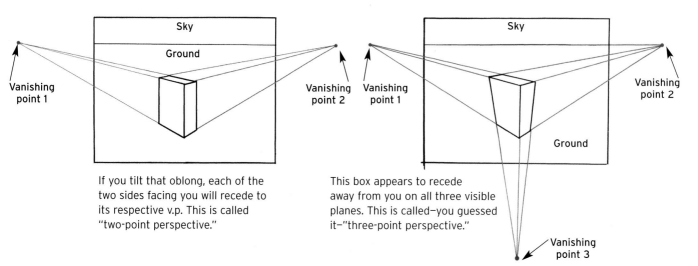

If you tilt that oblong, each of the two sides facing you will recede to its respective v.p. This is called "two-point perspective."

This box appears to recede away from you on all three visible planes. This is called—you guessed it—"three-point perspective."

Foreshortening

The receding of objects in space is known as foreshortening and is the most useful aspect of perspective for a character designer.

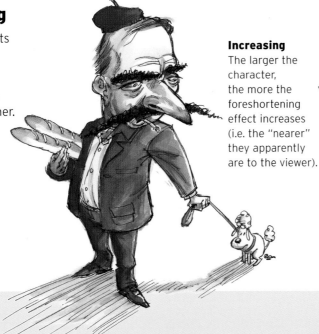

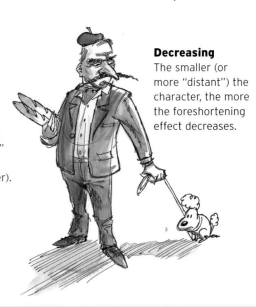

Increasing
The larger the character, the more the foreshortening effect increases (i.e. the "nearer" they apparently are to the viewer).

Decreasing
The smaller (or more "distant") the character, the more the foreshortening effect decreases.

Overlap

By stopping one curved line as it meets another, known as "tabbing," you can suggest one form in front of another.

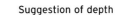

Wrong Right

Lines crossing
Allowing the lines to cross serves no purpose other than a decorative one.

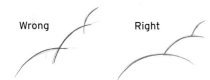

Wrong Right

Three dimensions
Each shape in this arm overlaps the one behind, giving it a three-dimensional quality.

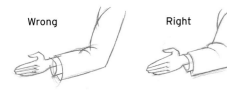

Depth
Depth is suggested by having the balls overlap each other while diminishing in size.

Twisting

Twisting a character or object creates depth in a drawing. Unless you deliberately want your characters to have no depth, avoid drawing them completely in profile or in a front view. If you must do this, at least add a little overlap or twist.

Flat

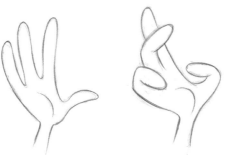

Flat Suggestion of depth Suggestion of depth

Surface

Folds, wrinkles, and patterns create the illusion of perspective contour on a surface.

Your character design is static. It cannot move around to express itself. It cannot speak. You can give it speech balloons, but still it has no voice. Your character must express itself through gesture.

Gesture, as in mime, involves the entire posture. In order to make a gesture clear, your drawing must have no confusing parts or ambiguities. Hence the importance of the body shape, or silhouette. The choices you make in determining the angle the character is seen from and how an action or attitude is depicted are called staging. Cartooning is a flat medium; you don't want your characters to look confusing or ambiguous on screen or paper, so you need to stage every action or attitude with maximum clarity.

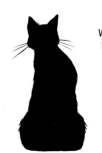

Well—it's a cat but that's all we can see.

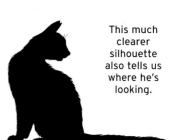

This much clearer silhouette also tells us where he's looking.

Silhouettes

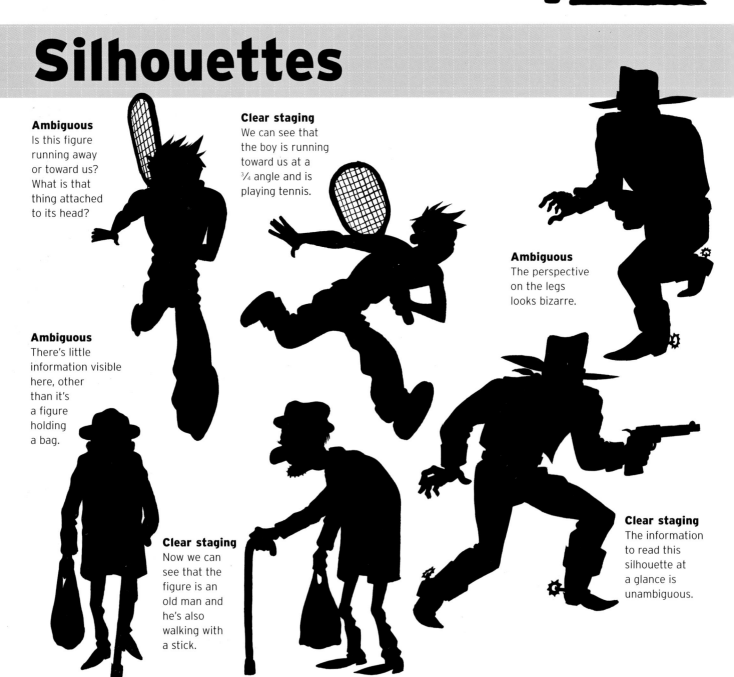

Ambiguous
Is this figure running away or toward us? What is that thing attached to its head?

Clear staging
We can see that the boy is running toward us at a ¾ angle and is playing tennis.

Ambiguous
The perspective on the legs looks bizarre.

Ambiguous
There's little information visible here, other than it's a figure holding a bag.

Clear staging
Now we can see that the figure is an old man and he's also walking with a stick.

Clear staging
The information to read this silhouette at a glance is unambiguous.

Simplicity and exaggeration

The key to all the silhouettes on these two pages is the same. Separate the component parts of the character as much as possible (for example, don't mask one leg behind the other) and keep their action out in the open. Imagine yourself as a mime or a silent-movie actor–every gesture should be exaggerated to some degree and readable to a viewer. Keep the details of the costume simple and exorcise any and every superfluous detail from the figures' outline, posture, and gestures. A profile or ¾ angle usually works best for clarity.

Pirate
Every detail in this silhouette is deliberate–the beard, the beer mug, the saber, the rolled-over boots–everything tells you this is a pirate. And a merry one.

Movement
You can tell that the boy and the girl are just ambling along by their gaits and (more subtly) the relative narrowness of their step.

Achieving clarity

Walt Disney told his animators to "Work in silhouette so that everything can be seen clearly. Don't have a hand come over a face so that you can't see what's happening. Put it away from the face and make it clear." With thought, planning, and experimentation, you should be able to draw any action or attitude so that it seems both natural and clear. If you take time to order your thoughts on paper, you will achieve your drawing goals with fewer mistakes and greater clarity. Slow down in order to speed up.

Man and dog
This is the perfect angle to draw the action of the man and the dog– their gaits, weight, attitude, and lines-of-action are all easy to read in a moment.

Hey presto! An utterly unambiguous image.

Heads and Faces

The human face is fascinating. Given the same ingredients of eyes, mouths, noses, and ears, there is an infinite amount of variation possible. No two faces are exactly alike—not even in "identical" twins.

Likewise, there are no limits to the different arrangements of features that you can invent when designing characters. Like a jazz musician, once you understand the basic anatomical structure of the face, you are free to create endless permutations on the theme.

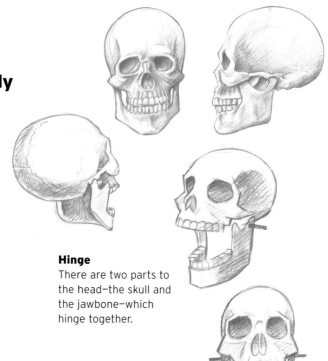

Hinge
There are two parts to the head—the skull and the jawbone—which hinge together.

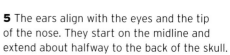

An average head and face

Start with a reasonably realistic average head (no two heads are identical, remember).

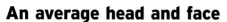

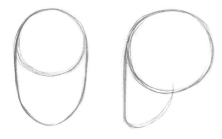

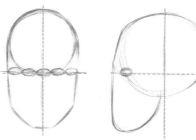

1 The face is a sort of oval with the lower part a little squared off.

2 Draw two bisecting lines through the face to divide it into quarters. The head is about five eye-widths wide. The eyes sit on the horizontal line with approximately one eye width between them.

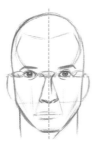

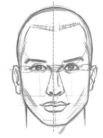

3 The nose is a triangle that starts on the midline, broadens out downward, and ends approximately three-quarters of the way down the face.

4 The lips meet about halfway from the nose to the chin. The corners of the mouth are at the base of an imaginary triangle that starts at the center point, touches the edges of the nose, and is directly beneath the center of the eyes.

5 The ears align with the eyes and the tip of the nose. They start on the midline and extend about halfway to the back of the skull.
 This technique will only create a face with generic features. See opposite for how to to vary this and inject a little interest.

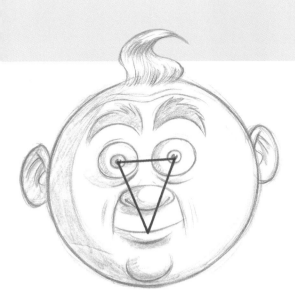

One circle, representing the head, with three variations: regular, attenuated, and flattened.

Attenuated.

Flattened.

And this eyes/mouth triangle, like the head shape, can be squashed or flattened.

Attenuated.

Flattened.

Making faces interesting

Human beings can recognize another human face from a great distance simply by seeing the triangle between the eyes and the mouth. Manipulate this triangle to create different configurations of facial features. Also change the shape of the head. We show what can be done with a circle on this page—but turn the page to see some other shapes.

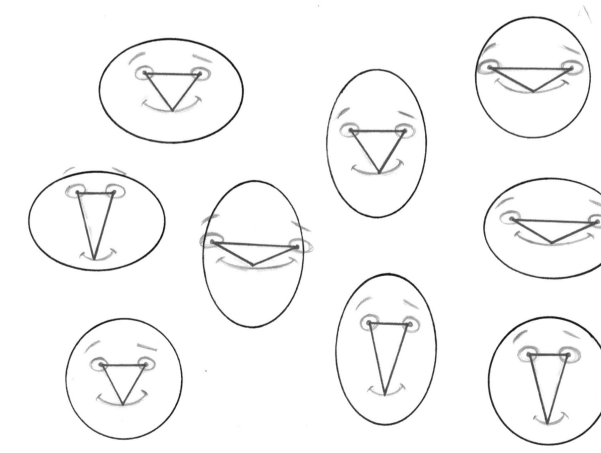

Manipulating heads and faces

By incorporating eye-mouth triangles (see previous page) into your three head types, you already have nine possibilities of facial configuration. And that's just with an oval head. You could also start with a square head, or a heart-shaped head, or one that resembles a peanut–the possibilities are endless. And you haven't even considered ears, noses, chins, dimples, eyebrows, cheeks, lip shapes, scars, freckles, beards, wrinkles, or hair!

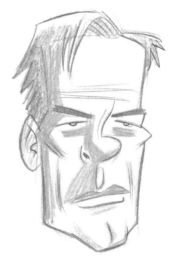

Boxer-type nose, slitted eyes, and a square jaw are used to convey a pugilistic nature.

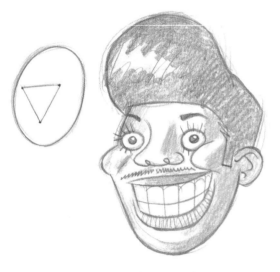

The eyes and mouth dominate this face to give the design a big, open, sunny disposition.

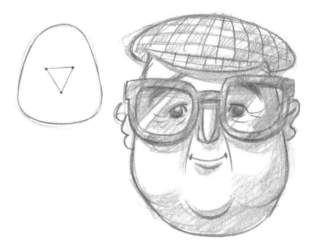

Juxtapose tiny eyes and nose with big spectacles for comic effect.

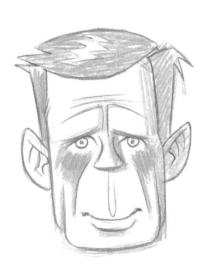

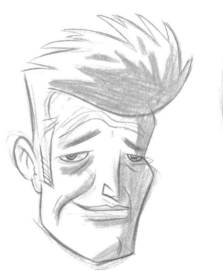

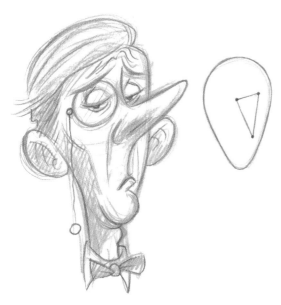

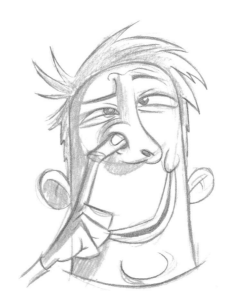

This "gentleman" conforms
to type—chinless and a
haughty expression.

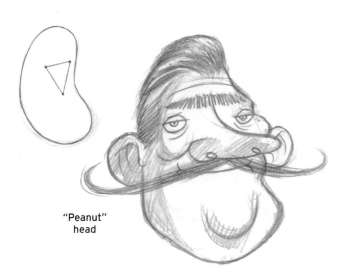

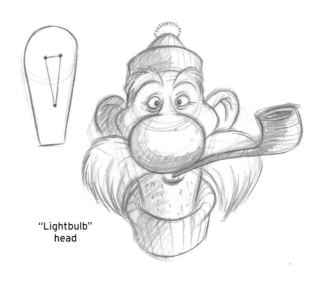

"Peanut"
head

"Lightbulb"
head

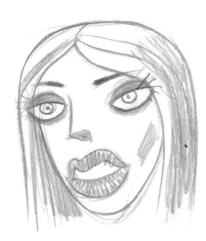

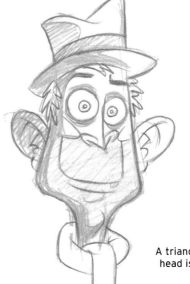

This combination of
overly large eyes and
mouth makes this pretty
face look vacant.

A triangular-shaped
head is tried here.

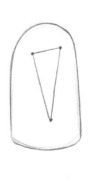

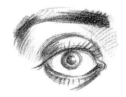
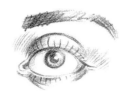

Facial muscles
The many tiny muscles around the eyes create a wide range of shapes and expressions.

Facial Features

A successful character design will draw you in and hold your attention. As with real people, you look first to the face of a character to find some point of interest, some clue to its intentions and personality.

The face is almost always the main focal point of any character design, and you should spend some time getting it "just so." The amount of emphasis you give to any particular feature will, of course, change the character of the face. Large eyes may give a face a juvenile or innocent quality, a high forehead may bestow intelligence, a flattened nose could suggest a boxer, and so on. Spending time sketching real faces will help give you an instinctive grasp of structure and build up your visual vocabulary of facial features and their permutations.

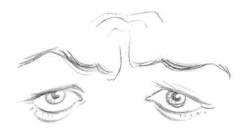

The muscles of the eyes and brow may push together, producing stress lines.

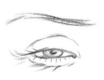

Partly closed eyes is a characteristic that humans share with cats to indicate pleasure or relaxation.

Eyes

Using squash-and-stretch, exaggeration, and distortion in our drawing, we can imply the whole spectrum of human emotion with just a few lines. Although some of these expressions are obvious ("shock," for example, or "rage"), there is no simple formula to express any given emotion; facial expressions change with different cultures and personalities. Try to find a distinctive way of making your characters expressive in their own individual way.

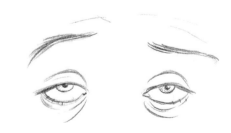

Tiredness? Exasperation?

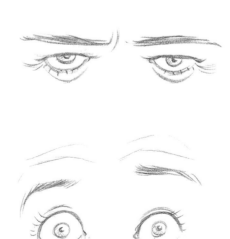

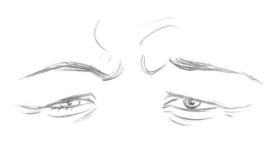

Pain? Distress?

In extreme shock, the brows raise and the eyes pop open to take in new information.

Socket
Two-thirds of the eyeball is protected within the socket.

Eyelids
The eyelids curve around the eyeball and protrude no matter what angle they are viewed from.

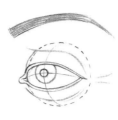

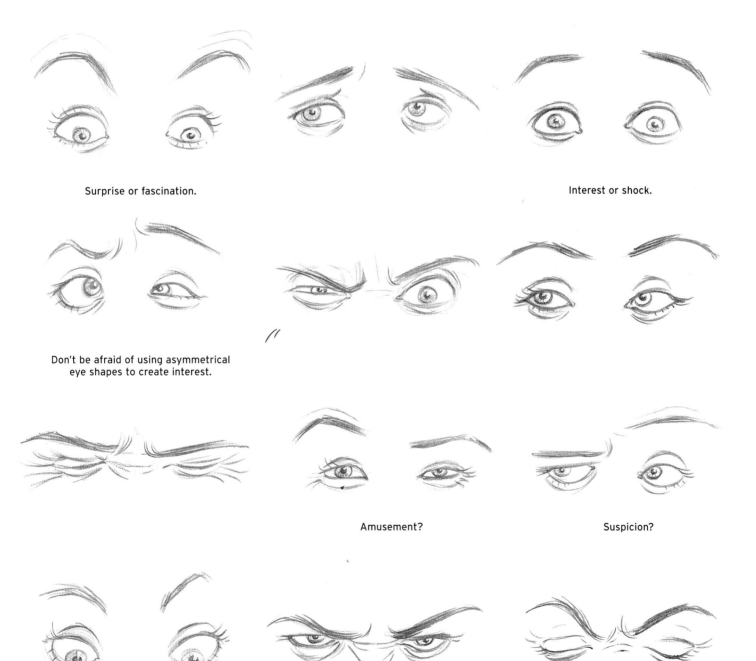

Surprise or fascination.

Interest or shock.

Don't be afraid of using asymmetrical eye shapes to create interest.

Amusement?

Suspicion?

Extreme compression of the eyes coupled with canine-type nose wrinkling may suggest a state of fury.

Facial variation

Here are four head constructions that utilize exactly the same features, but by positioning the eyes in various positions, four completely different faces start to emerge.

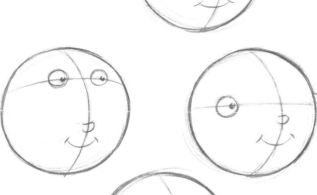

Unified eyes and brows

Disney animator Freddie Moore preferred to draw the eyes and brows as a single unit that centers around the pupil. It gives a cartoony yet cohesive look to the eyes.

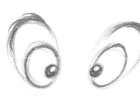
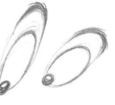
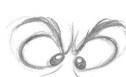

Here, white voids surrounded by angular black shapes suggest menace, evil, or perhaps something supernatural.

Floating pupils

Much can be said about the character's state of mind with just a little information in the eyes. A floating pupil gives a dazed look. It can also deaden a face, so be careful how you use it.

Acting

There's enough construction in these eyes to stretch your character's "acting."

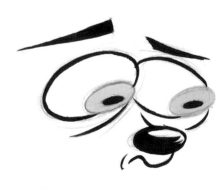

Innocent appeal

You'll struggle to inject anything subtle into an eye design like the one above, but it is easy to read on a cartoon face and has an innocent type of appeal.

These eyes are basically upside down, which gives them an odd, disconcerting appearance.

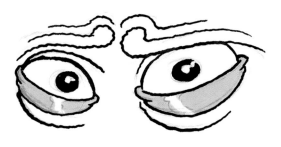

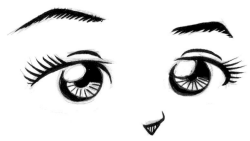

Dot eyes limit expression change, so the brows become more important.

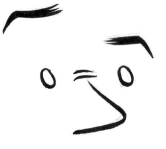

The tapering black corners are a quick way of implying mascara.

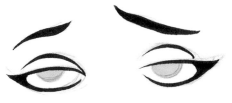

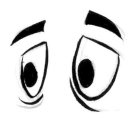

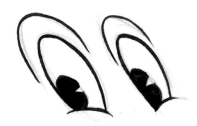

Here, the eye make-up is thickly exaggerated; they could be the eyes of a stripper or a drag queen!

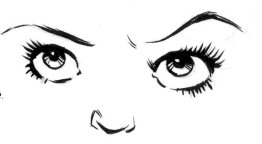

This design is too complex for traditional animation, but is highly suitable for comics or illustration.

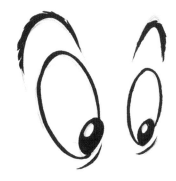

Positioning

Don't get too hung up on where to position the eyes on a face. As a rule try to keep them level with each other (unless designing aliens, freaks, or Quasimodo) but if you design a face with the eyes high and touching, and it works, then don't worry about what you've read never to do in the anatomy books—it's character design, not life-drawing.

Mouths

People use their mouths to talk, kiss, eat, breathe, and emote. The lips lie directly over the teeth (assuming a character has them) and can be manipulated into many different shapes by a circular band of muscle that surrounds the mouth. As with the eyes, the mouth is particularly important for the finer points of your character's "acting" potential, so you must consider how much a factor this will be when designing, particularly for animation. The lips and teeth can be drawn simply, or more realistically, or even for just a comic effect.

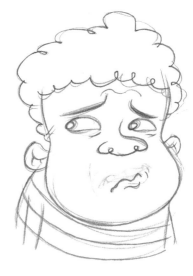

Oversized
This face, and in particular the mouth, has more than enough construction in it for most of the acting demands of full animation; the mouth and teeth here are comically oversized, but retain elements of real anatomy.

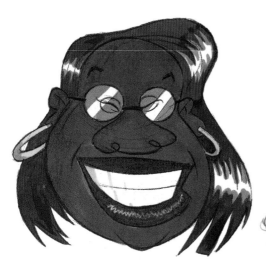

Misshapen
There are no rules about being consistent with the design of any detail on a character. For example, this dog's teeth get more misshapen the angrier he gets.

Simplified
The teeth can be drawn as simple bands of white that suit the cartoon simplicity of this design.

You can make the mouth pout...

or snarl...

or look worried.

Mouth chart

If you are designing for T.V. animation and the character
has to speak, you may also have to produce a mouth chart.
The following shapes can be used for all the vocal sounds
(or phonemes) produced in dialogue.

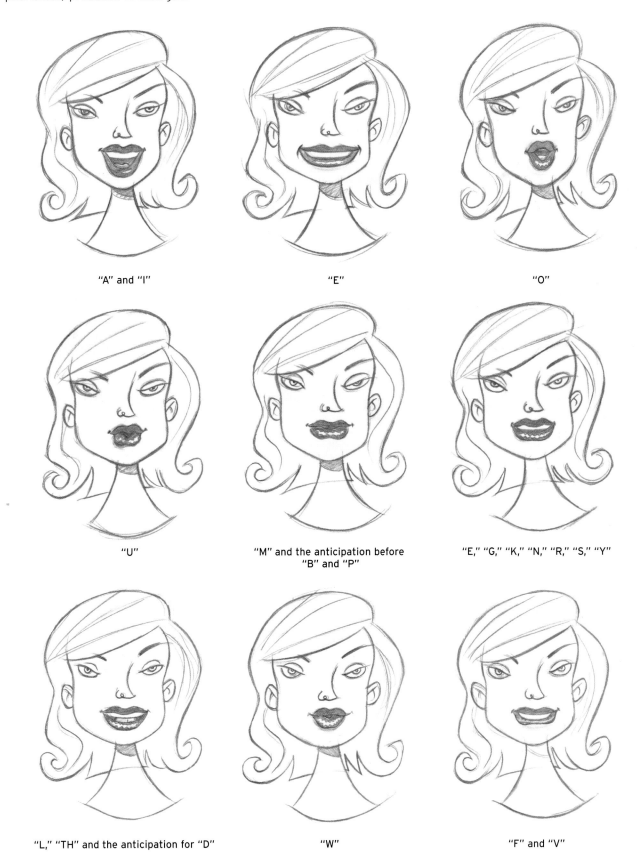

"A" and "I"

"E"

"O"

"U"

"M" and the anticipation before
"B" and "P"

"E," "G," "K," "N," "R," "S," "Y"

"L," "TH" and the anticipation for "D"

"W"

"F" and "V"

Facial hair

An interesting 'tache on a comedy character never hurts—think of Charlie Chaplin, Groucho Marx, and Oliver Hardy.

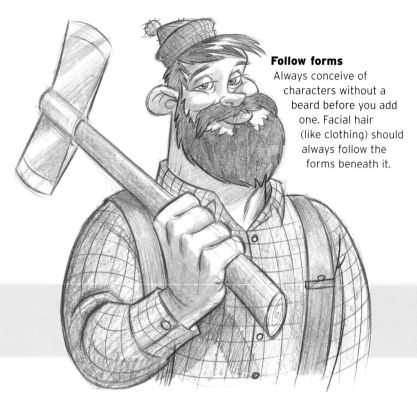

Follow forms
Always conceive of characters without a beard before you add one. Facial hair (like clothing) should always follow the forms beneath it.

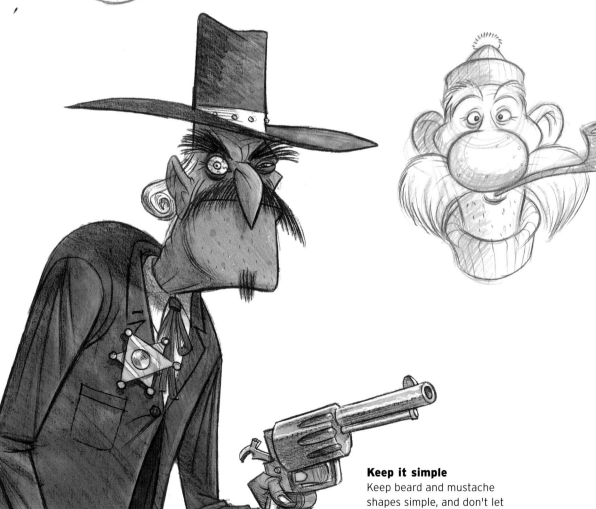

Keep it simple
Keep beard and mustache shapes simple, and don't let them clutter up a strong face.

Hair

As with lines and wrinkles on a face, aim to draw hair simply. Try to convey the feeling of hair without drawing every strand.

Variation

If a character has spiky hair, vary the shape and size of the spikes.

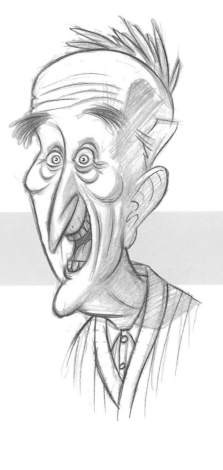

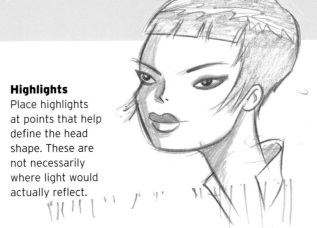

Highlights

Place highlights at points that help define the head shape. These are not necessarily where light would actually reflect.

Spectacles

As with facial hair, always design the face before adding the spectacles. Sunglasses may look cool, but never use them as an excuse to avoid drawing the eyes.

Personality

Never lose an opportunity to tell the viewer more about a character. Adding the tape to the hinge of the spectacles gives a small clue to this guy's personality.

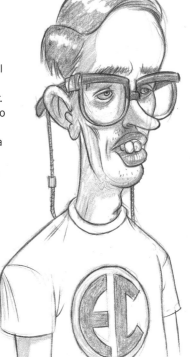

These sunglasses won't impede or obscure this character's facial expressions.

Ears

The ears are positioned on the side of the head (usually!) and are shaped like shallow bowls to help amplify sound. They are formed from four areas of cartilage and the fleshy lobe.

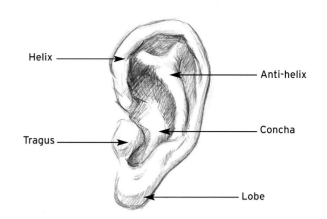

Helix

Anti-helix

Tragus

Concha

Lobe

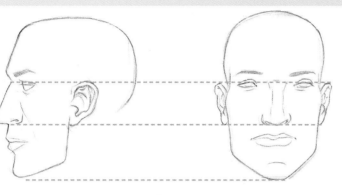

Position
In profile, the front of the ear lines up with the jawline at the midpoint of the skull.

A rough guide for positioning ears is to line them up with the eyes and the tip of the nose.

A unique feature

Like fingerprints and the retinal patterns of the eye, every ear is unique. Some portrait paintings have been declared genuine or forgery based on a careful study of how the artist painted the ears. The theory is that every artist only paints versions of their own ears. What must the designer of Mickey Mouse have looked like?

Cartoon renderings

Keep the style of the ears consistent with the rest of the character. The more cartoonish the overall design, the simpler and more abstract the design of the ear can be.

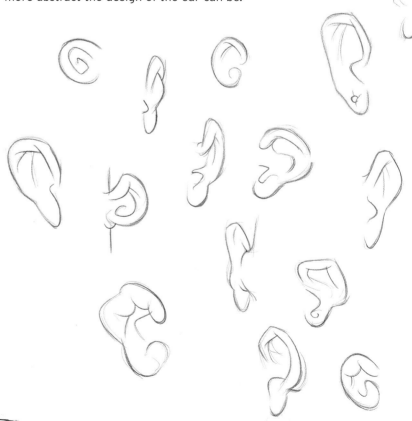

Noses

The nose is (usually) a triangular protuberance that sits in the middle of the face. Only the upper half is bone; the rest is formed from five pieces of cartilage, which give a nose its distinctive shape.

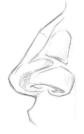

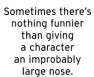

It's almost a cliché to put a Roman nose on a Roman character, but it gives a sense of haughtiness, so why not?

Sometimes there's nothing funnier than giving a character an improbably large nose.

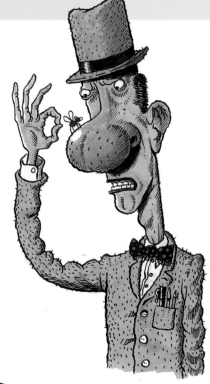

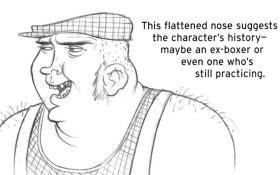

This flattened nose suggests the character's history—maybe an ex-boxer or even one who's still practicing.

This nose is cute as a button and a counterpoint to the size of the ears.

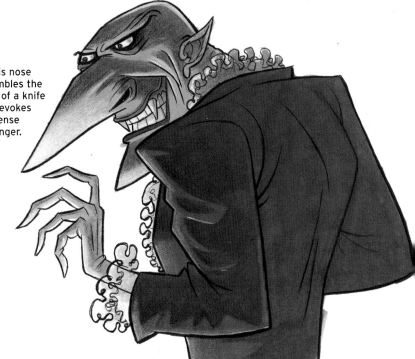

This nose resembles the blade of a knife and evokes a sense of danger.

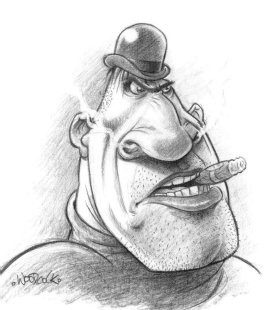

Flared nostrils enhance a menacing appearance.

Characterization

Where do new characters come from? Thin air? A sudden burst of inspiration? Well, sometimes, if you're lucky. But frankly, life is way too short to sit around waiting to be hit by creative lightning. The best way to engage your imagination or to find an idea is to start drawing. Animator Dick Williams believes that we learn through osmosis and that if we soak up as much visual and technical information as we can, sooner or later it will filter through our personalities and reemerge as new ideas and techniques. Your subconscious is teeming with faces, figures, and ideas for characters, so you need to find ways of unlocking that treasure chest and letting the images tumble out. This chapter covers practical methods for creating designs before moving on to the most popular character types in animation and comics.

The conscious mind often acts as a censor, but you can turn it off simply by preoccupying it with the practical process of seeing and making images.

Getting Inspired

"We should be taught not to wait for inspiration to start a thing. Action always generates inspiration. Inspiration seldom generates action."

Frank Tibolt, author

Start to trigger your visual cortex (the part of the brain that recognizes forms and object representation) and more importantly your imagination by leafing through comic books or photographs of faces, sporting activities, animals, or anything you care to look at. Find something that interests you and start sketching loosely and spontaneously. When you feel comfortable, put aside the reference material and continue with your own train of thought. By starting to draw, you will engage your subconscious and ideas will start to come to you. One thought will provoke another until you find ideas forming and characters taking shape. Although it may have a serious application, creativity should be playful by nature; find ways of having fun with your drawing and improvement will follow.

Building a reference library

Unless you are blessed with a photographic memory, you will find that you regularly need to look at reference material, whether for inspiration or information. Keeping that material near to your workspace will save you time and trouble, but not necessarily money.

Comic-strip artists and many illustrators traditionally referred to their reference files as a morgue—somewhere to store the "bodies." They clipped useful or inspiring photographs, graphics, and illustrations from magazines and newspapers and stored them alphabetically in filing cabinets ready to be studied, or drawn from, or traced. This is still a very cheap and useful way of accumulating reference material, but there are now other options as well.

Internet

The easiest solution for anyone with a computer is to download interesting photos and artwork and save them to your hard drive. Almost anything you can think of is floating out there in cyberspace. Many of your favorite artists, designers, and film studios will have their own Web sites, or will have sites devoted to them, with images that can be found nowhere else. The Internet is also a great place to check out new character design.

Books

Unless you know of some good secondhand bookstores, you should be very selective about which books you buy. Wonderful books are published on all of the arts, but they are usually very expensive, so choose wisely. A reference library may consist of: many hundreds of comic books; scrapbooks of other artists' work cut from newspapers and magazines; photocopies of animation drawings (and a few originals); photocopies of model sheets (from studios such as Disney, Warner Brothers, and MGM). It should also include reference books dealing with subjects such as cinema, actors, animation, wildlife, natural history, history of comics, sports photography, graphics and illustration, fine art, historical costume, cars and motorcycles, and dinosaurs. You may also collect children's fiction. Of all these books, the ones on natural history, animation, portrait photography, and actors may be the most useful. Sketching and caricaturing real people can be a worthwhile starting point to finding a face or persona.

Reference
Your own personal library may consist of comic books, reference books, and children's fiction, to give a few examples.

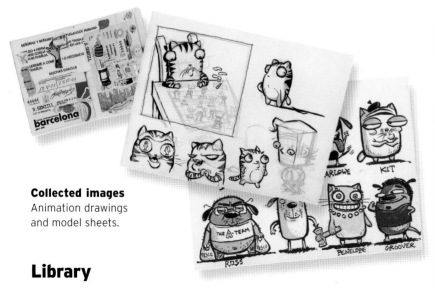

Collected images
Animation drawings and model sheets.

Library

Your local library will have many useful reference books. Photocopy anything useful and bring it home to file away.

Reference material

1 A copyist is just another term for a hack artist.

2 The golden rule is never copy someone else's work; it devalues you and your artwork and destroys any feelings of self-worth.

3 However, feel free to be inspired by someone else's approach to staging, lighting, use of color, design sense, choice of materials, etc. Study, analyze, and find a way of making it your own.

Caricature

Many great animators and cartoonists are also skilled caricaturists. The art of caricaturing has many facets: solid draftsmanship, observational skills, a sense of the absurd, and the ability to empathize with the subjects—to try (if only briefly) to see life as they do.

This last skill is most important to the character designer. A great character design is not simply an arrangement of shapes and colors, but the distillation of a personality into a drawing.

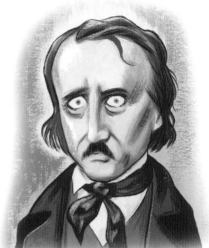

Restrained
This restrained caricature was built up with drybrushed gouache and flat blacks.

Minimal
Only minimal exaggeration is used in this gouache illustration, apart from the floating "scary" pupils.

Graphic
A simple, graphic treatment using ink and marker that emphasizes the nose and mouth.

Spiky
A lot of sharp lines are used here, with marker over photocopied pencil, to emphasize the spikiness of the subject.

Stretched
Most of the exaggeration here is around the middle section of the face. The nose has been stretched and the mouth size reduced to contrast with it.

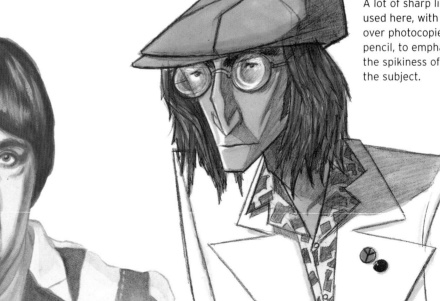

Cartoony
The style of this caricature is almost cartoonish, with lots of contrasting textures and linework to frame a very pretty face.

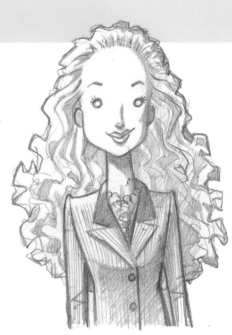

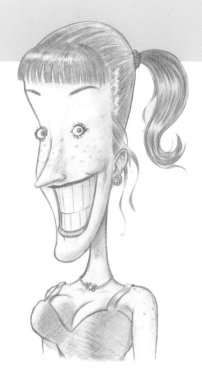

Creating caricatures

Developing your skills as a caricaturist will help emphasize personality in your designs and may even give you the look of a character. An amusing caricature is not a character design as such, but you can use it as a springboard in creating your own.

Emphasis

Find a subject (from life or a photo) and make an initial caricature. Continue by making successive caricatures of your caricatures, trying with every drawing to add emphasis to the most interesting features or the expression. Try to find the personality behind the face. This is an interesting work method if you're aiming for something a little bizarre.

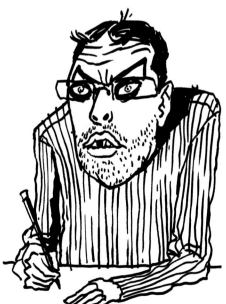

1 The first drawing is a quickly-sketched cartoon version of someone observed from life.

2 Using only the initial sketch to work from, any interesting features such as the bags under the eyes or the open mouth are made more extreme.

3 The final version is a long way from the original sketch. We now have an original and very quirky character.

Finding a face

The object of this exercise is to arrive at an unusual face without becoming too extreme. This image was chosen because the author needed to design a heavy—a thug—and there's something tough about this face. First, try a straight caricature and then try the squashed and attenuated heads idea from page 45.

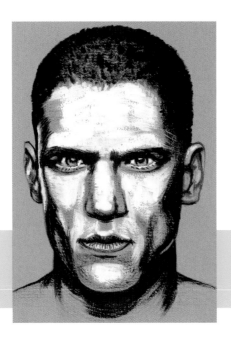

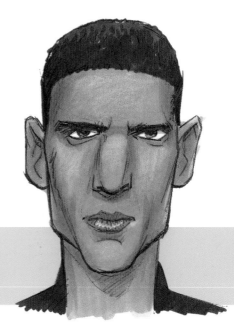

Hmmm. It's still too naturalistic, too much like the original.

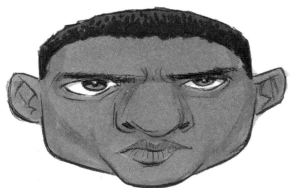

A squashed caricature.

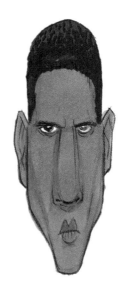

Attenuated.

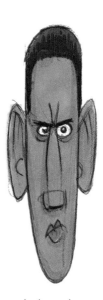

And a cartoon version.

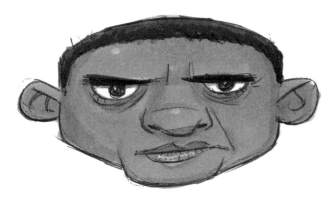

And a more "cartoony" version.

Features triangles

The heads are OK, but nothing special. Something else is needed to spice up the design. Try incorporating the three features triangles.

H1

H2

H3

F1

F2

F3

Collected images
These heads and features shapes can be combined in any permutation.

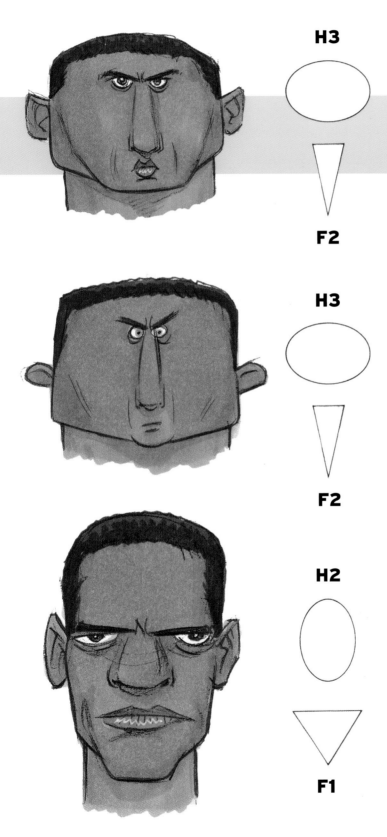

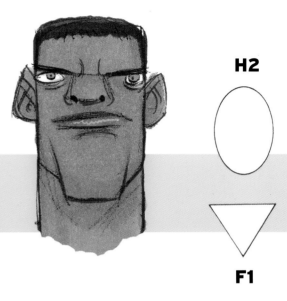

H3

F2

H2

F1

Keep going and see what turns up.

H3

F2

H2

F1

Drawing tips

1 Don't get hung up on achieving a likeness. You're trying to make something new.

2 Try to work from faces with character and personality—it gives you a head start.

3 Work loosely and allow mistakes to happen—these are often serendipitous. Give your unconscious the freedom to guide your hand.

4 The graphic treatment of the face is not important. Draw freely and purposefully with whatever medium you fancy.

5 Making smaller drawings saves time and lets you concentrate on bold shapes. Draw bigger when you are working out the detail.

6 Blowing up your thumbnails on a photocopier helps retain the vitality of your first sketch while giving you the room to work into it.

7 You can use the same process when designing your characters' physique, clothing, and so on.

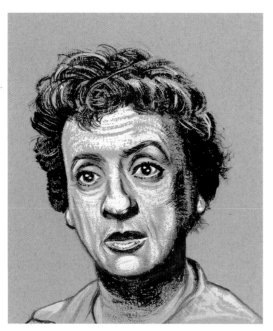

Her features are large and expressive.

Using a real face

It can't be emphasized enough that drawing and designing should be enjoyable processes. There should always be a sense of playfulness in your work to allow your creativity to flourish and new ideas to form. In this example of working from reference material, the author had no preconceived idea of where he wanted to end up—he was just allowing each successive drawing to suggest another. He started with a realistic portrait based on a photograph.

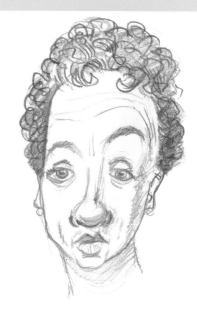

1 A fairly restrained drawing to start, but allowing the asymmetry in her face to become more noticeable.

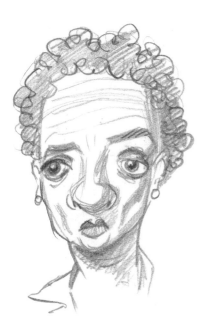

2 Taking the face a little further from the original photo reference now by pushing the shapes and enlarging the features for comic effect. Not attempting to find a character yet—just playing with a face.

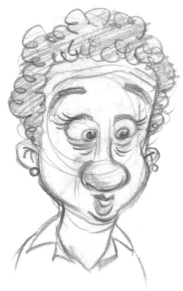

3 No longer looking at the original reference at all, the angle of the face is now "flopped" to keep from being too literal and to see what happy accidents may arise. Still keeping the drawing simple, simple, simple... but starting to feel stuck with Mildred's puppy-dog features. Wait a minute!

4 Now, the makings of a character that could be further refined and a direction to pursue to find other characters.

The art of exaggeration

In these last three drawings, I've returned to the original reference and tried to separate out and exaggerate any visual oddities in the face.

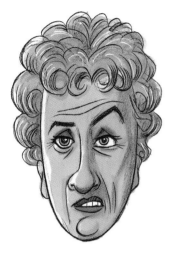

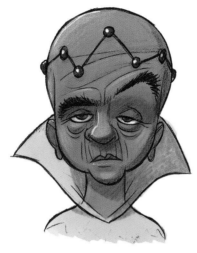

Meaner
This face exaggerates the tiny hint of hardness in the original expression to find a slightly meaner, and perhaps sarcastic, personality.

Sci-fi
Anything is possible—so lose the hair, add some sci-fi type costume details, and the result is a genderless, master-of-the-universe type alien.

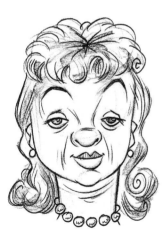

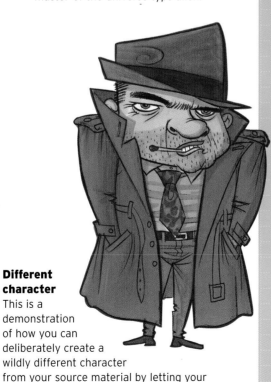

Sassier
Longer hair and a little softness in the face gives us a sassier character.

Different character
This is a demonstration of how you can deliberately create a wildly different character from your source material by letting your imagination run free. The changed gender and the new body and costume suggest a cartoon gumshoe. But if you look carefully, the face is still very much inspired by the reference material.

Drawing tips

1 Draw from life and photo references as much as you can.

2 Find caricaturists' work that you admire and try to analyze their graphic style. Remember, every artist has a box of tricks that they draw upon to unify their style and make their drawings pleasing to look at; learn from their examples.

3 Practice quick-sketching likenesses; try to memorize a face in as short a time span as you can, and then draw it from memory.

4 After making your studies, put the reference material to one side and draw from initial sketches—or, even better, your imagination.

5 Try any idea that occurs to you, no matter how far out in left field—it may work.

6 Combine characteristics from more than one source (for example, those ears on that head)—it may work.

7 If you find that you struggle to draw a particular thing—for example, a knee joint or a thumb—then spend more time drawing that thing until you can do it confidently from the imagination.

8 Try to work quickly and freely but with a sense of purpose. And if a drawing doesn't work, throw it away. Never waste your time laboring over a drawing that you know is going nowhere.

9 Avoid tracing over your drawings on a lightbox until your very final clean-up because you must try to retain vitality and looseness in your design. Sometimes the spider-scrawl of loose pencil work will give you a better mass or shape or telling detail.

10 Finally, KISS! (Keep it simple, stupid!)

No character can be represented simply by the way they look. In fact, your design cannot be called a character design until you have imbued it with aspects of a personality. It is only through personality that a viewer can respond to a character—and personality is always expressed through action.

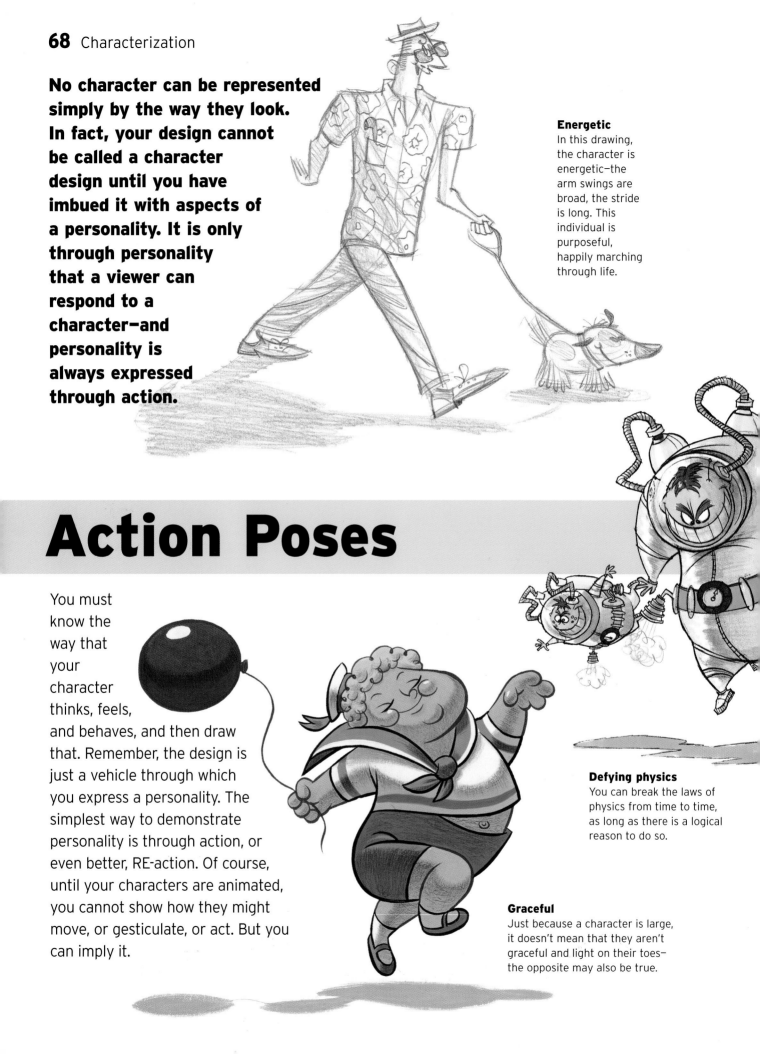

Energetic
In this drawing, the character is energetic—the arm swings are broad, the stride is long. This individual is purposeful, happily marching through life.

Action Poses

You must know the way that your character thinks, feels, and behaves, and then draw that. Remember, the design is just a vehicle through which you express a personality. The simplest way to demonstrate personality is through action, or even better, RE-action. Of course, until your characters are animated, you cannot show how they might move, or gesticulate, or act. But you can imply it.

Defying physics
You can break the laws of physics from time to time, as long as there is a logical reason to do so.

Graceful
Just because a character is large, it doesn't mean that they aren't graceful and light on their toes—the opposite may also be true.

Imparting reality

To elicit sympathy for, or interest in your characters, you must make them believable. In order to be believable, they must react to gravity in the way that real animals and people do. Without gravity to anchor your character it will have an aimless, floaty appearance on the page and will never be believable. Connect your characters to the ground by drawing plausibly how their weight is supported. Or, if you show them mid-leap, imply where they leapt from and where they will land.

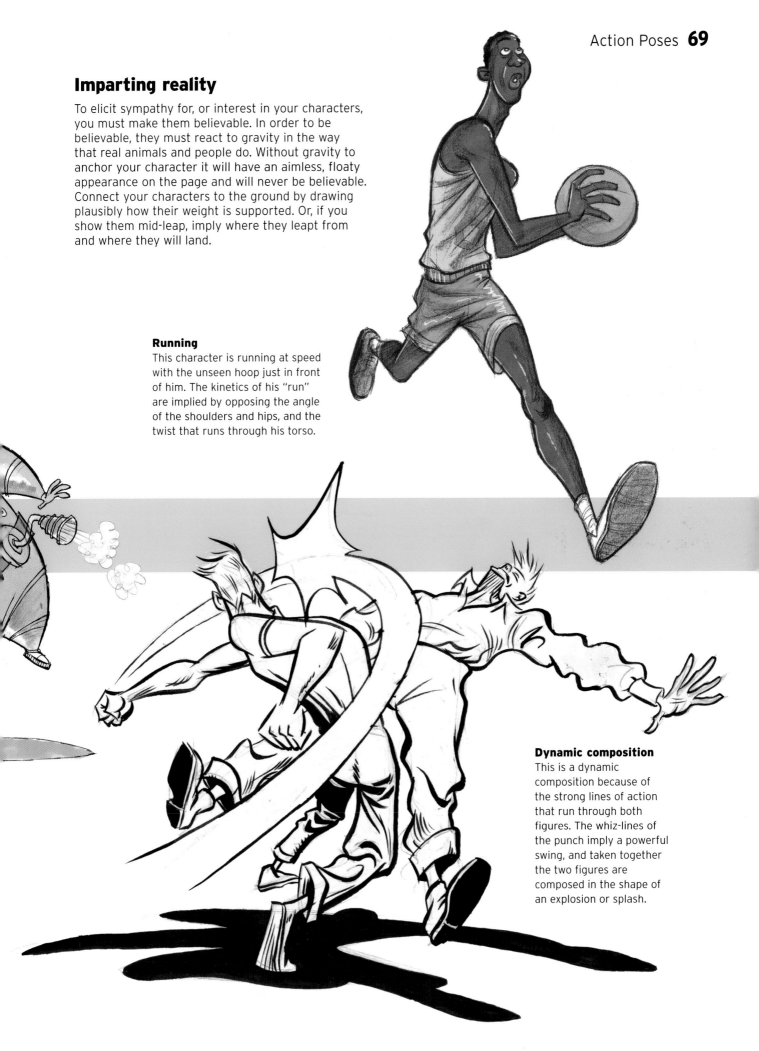

Running

This character is running at speed with the unseen hoop just in front of him. The kinetics of his "run" are implied by opposing the angle of the shoulders and hips, and the twist that runs through his torso.

Dynamic composition

This is a dynamic composition because of the strong lines of action that run through both figures. The whiz-lines of the punch imply a powerful swing, and taken together the two figures are composed in the shape of an explosion or splash.

Describing the essence

In all of these poses of an energetic boy character, care has been taken to reduce down the specific action to its essence and then exaggerrate it to the point where that exact pose would be nearly impossible to achieve in real life.

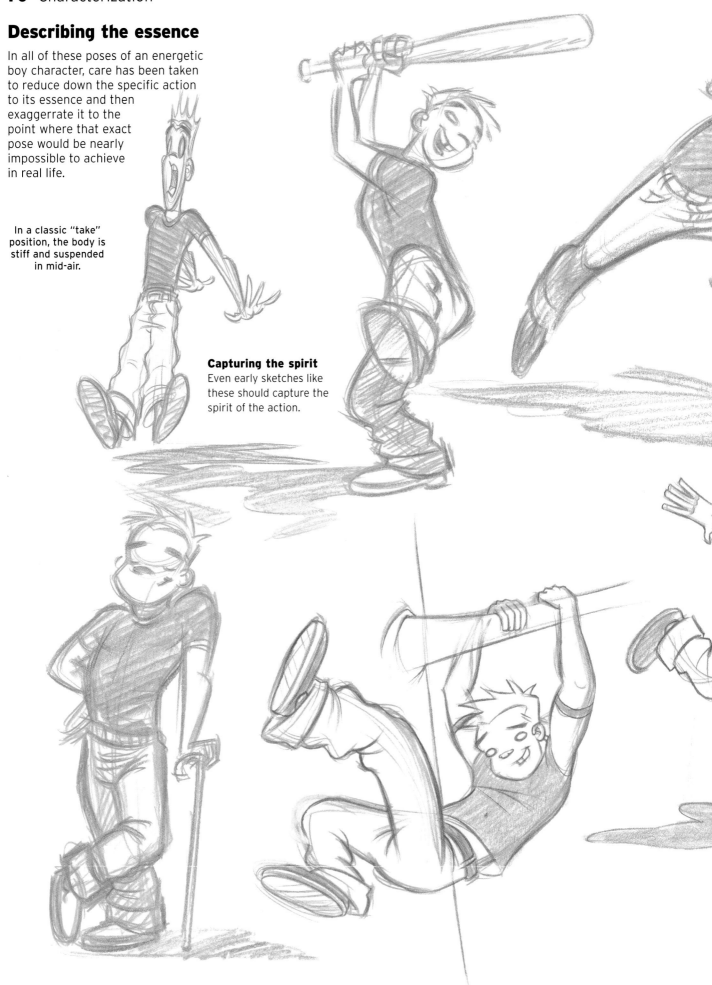

In a classic "take" position, the body is stiff and suspended in mid-air.

Capturing the spirit
Even early sketches like these should capture the spirit of the action.

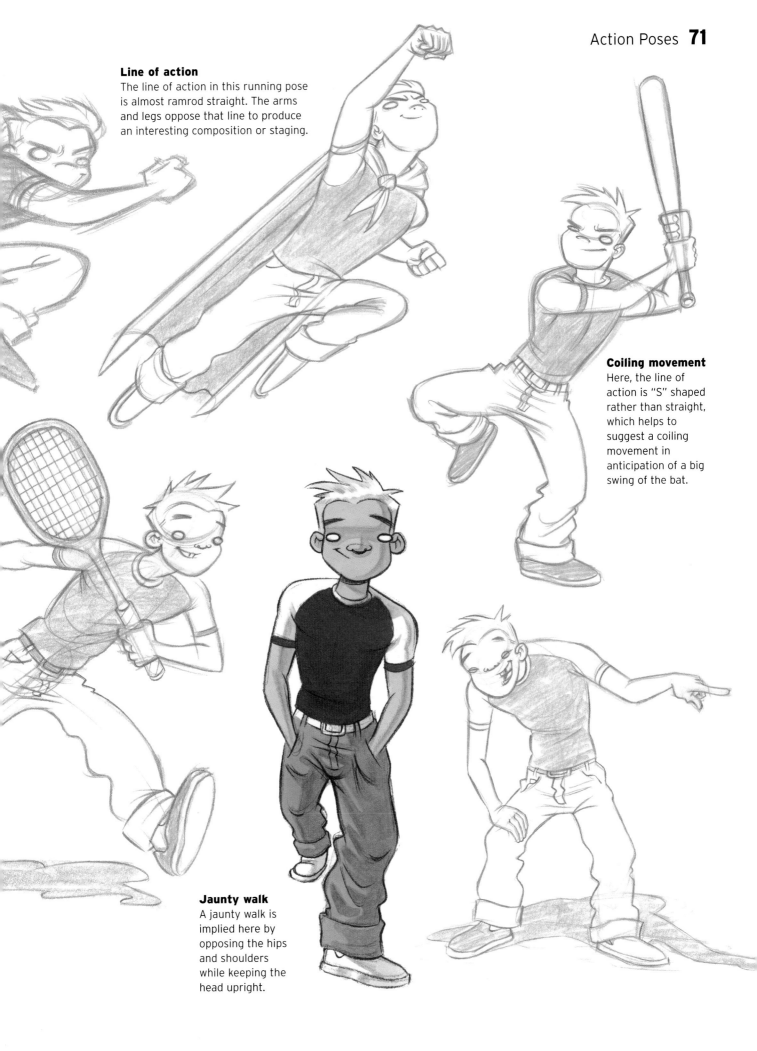

Line of action
The line of action in this running pose is almost ramrod straight. The arms and legs oppose that line to produce an interesting composition or staging.

Coiling movement
Here, the line of action is "S" shaped rather than straight, which helps to suggest a coiling movement in anticipation of a big swing of the bat.

Jaunty walk
A jaunty walk is implied here by opposing the hips and shoulders while keeping the head upright.

The art of cartoon acting is really the art of pantomime. In much the same way as silent film comedians like Chaplin or Keaton, cartoon characters act with their entire body; their posture conveys their emotions, their gestures amplify the emotions, and their facial expressions confirm or qualify them.

Acting

Although strong readable postures, gestures, and expressions are desirable, it certainly doesn't mean that the acting has to be melodramatic or cornball. Context and juxtaposition can help subtly shade a character. This can be done in a purely pictorial way.

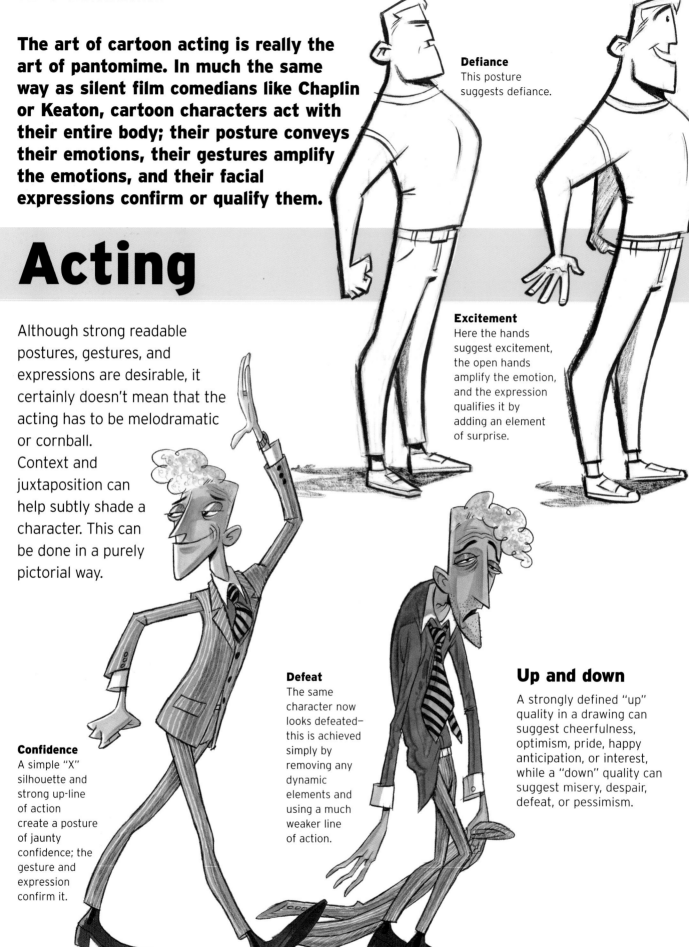

Defiance
This posture suggests defiance.

Excitement
Here the hands suggest excitement, the open hands amplify the emotion, and the expression qualifies it by adding an element of surprise.

Confidence
A simple "X" silhouette and strong up-line of action create a posture of jaunty confidence; the gesture and expression confirm it.

Defeat
The same character now looks defeated—this is achieved simply by removing any dynamic elements and using a much weaker line of action.

Up and down

A strongly defined "up" quality in a drawing can suggest cheerfulness, optimism, pride, happy anticipation, or interest, while a "down" quality can suggest misery, despair, defeat, or pessimism.

Open and closed

The outer posture, gesture, and expression of a character can suggest their inner emotional register. In general, an open posture (or gesture) is a positive signal, showing the degree of a character's happiness, interest, or responsiveness to other characters or to their environment. A closed posture and gesture show a negative emotional state, such as annoyance, jealousy, wounded pride, or boredom.

Closed
This character is completely disengaged. He is hostile, unwilling to listen, and guarded.

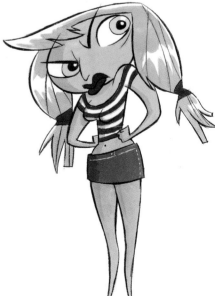

Open
Every aspect of this character suggests openness. He is attentive, listening, and open to new information.

Contrast and character

Sometimes people lie with their expressions. For example, a man may laugh when his boss tells a joke he doesn't find funny. When posture and expression are in conflict, it gives dramatic tension to a pose or to a situation between characters. The contrast between posture and expression suggests a personality inside the design and engages the viewer's interest. Vary the degree of open/closed posture in a character and find ways of contrasting it with the facial expression.

Character without dialogue

Even if you're pleased with your finished design, it may still look a little lifeless on the page. Try placing characters in dramatic scenarios that will allow their personalities to emerge. Although it may be tempting to add dialogue or speech balloons, try to encapsulate a moment or situation using only pantomime or body language. The following four examples are all staged and "acted" to strongly suggest what the characters are thinking.

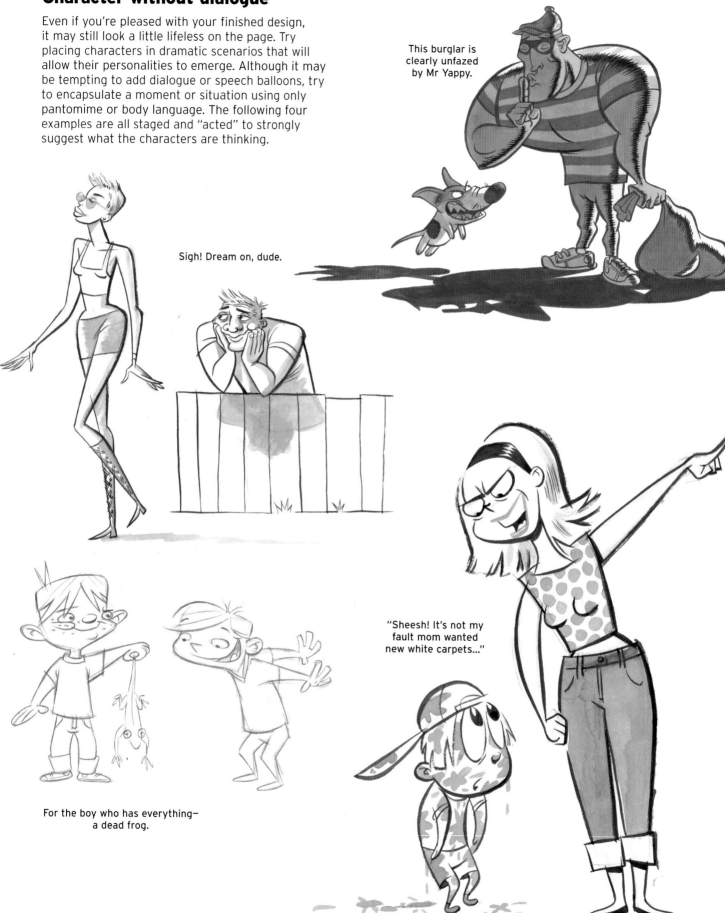

This burglar is clearly unfazed by Mr Yappy.

Sigh! Dream on, dude.

"Sheesh! It's not my fault mom wanted new white carpets..."

For the boy who has everything— a dead frog.

Bring your character to life

The poses on this page represent a fairly typical one-page model sheet. The look of this character is strongly graphic, but not so much that it limits his acting possibilities or expressiveness. (The inspiration for this design literally happened over lunch—he's based on a spring onion!) Having chosen quirkiness over realism in this design (the details of his features and anatomy are only vaguely plausible and his hair has a life of its own!), it becomes more important that his personality is strongly suggested.

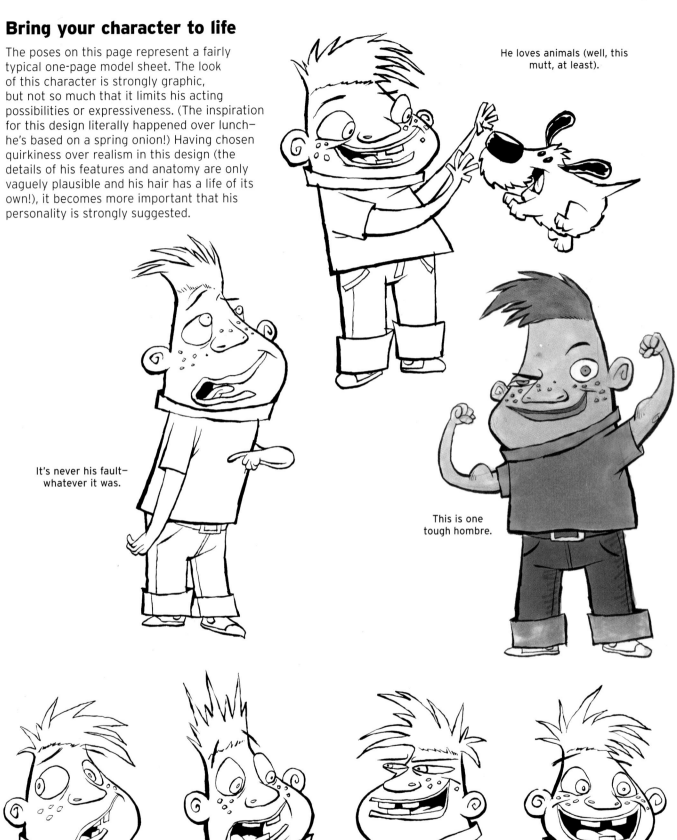

He loves animals (well, this mutt, at least).

It's never his fault—whatever it was.

This is one tough hombre.

Expressions

His features are very large and mobile, which helps to make the expressions punchier and easier to read.

Facial Expressions

In all animals (particularly the human variety) facial expressions are a form of non-verbal communication. They can vary from expressively large and easy to read to subtle and ambiguous. They can be voluntary or involuntary, and, when amplified or qualified by posture and gesture, can convey every facet of human emotion, even individual thoughts. There are five basic or strong expressions.

Joy

Sadness

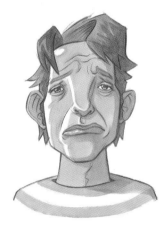

Fear

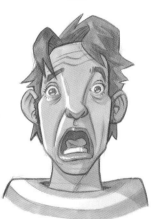

Anger

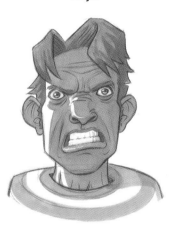

Disgust

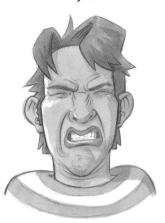

"Being a robot's great, but we don't have emotions, and sometimes that makes me very sad."

Bender the robot, "Futurama"

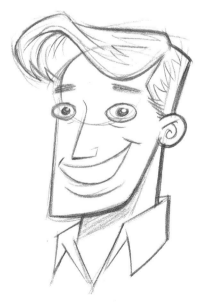

Fake
A voluntary smile is made only with the mouth.

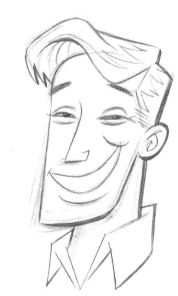

Genuine
An involuntary smile uses the eyes as well as the mouth. Crinkle the eyes and compress them upward.

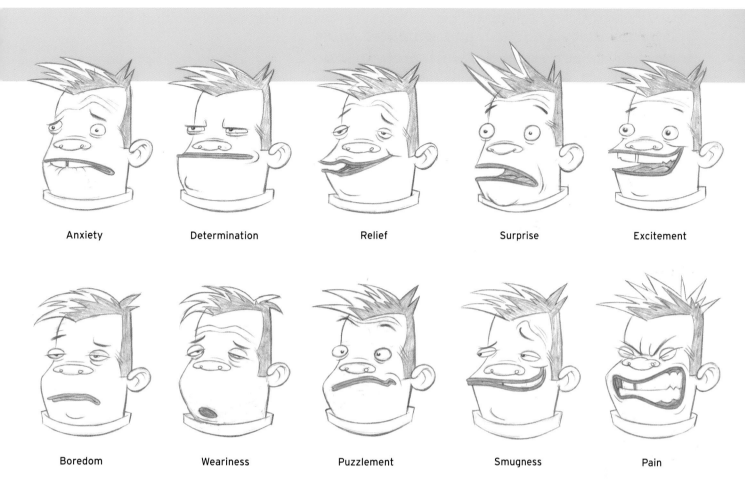

Anxiety Determination Relief Surprise Excitement

Boredom Weariness Puzzlement Smugness Pain

Observation

Because your stock-in-trade as a character artist is exaggeration based on observation, you may find these bolder expressions easier to draw. But there are many others—and you need to be able to utilize all of them. Try to take mental snapshots of people's expressions as you see them, and practice drawing them later in your sketchbook.

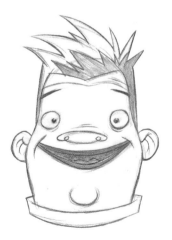

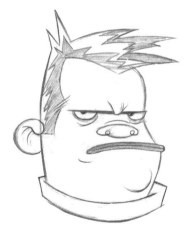

Open and closed

As with posture and gesture, facial expressions can vary between being open or closed, receptive or unreceptive. Be aware that many expressions can be ambiguous and may need confirming with gesture and posture.

Open
The wide and attentive eyes, the raised brows, the slight smile are all signals that this person is interested and open to new information.

Closed
This character's expression says, "I don't care what you have to say. I'm angry. I'm not listening."

Children's stories, comics, and animated films have always been populated with archetypes. The very best, the most memorable, of these stereotypical characters were the ones whose creators managed to escape from cliché by giving each a unique visual appearance and personality traits. Many of your characters will fall into the categories on the following pages, but with imagination and a fresh approach you can always find a new twist to an old formula.

"Let's have some new clichés"

Samuel Goldwyn, movie producer

Character Types

Babes

There's no real formula for drawing the babe character, although many share certain—um—characteristics. A babe can be sweet, sassy, vampish, innocent, sultry, tall, short, svelte, or fleshy; gymnastic, helpless, sharp or dizzy, coy, or cunning. It certainly helps if she's pretty (and a revealing costume is never a bad thing) but really it's the personality that always counts. Well—usually...

Attitude
Designing a sexy or sassy girl is as much about exaggerating her posture and attitude as her features or physique.

A 50s-style babe with the hourglass figure associated with that era.

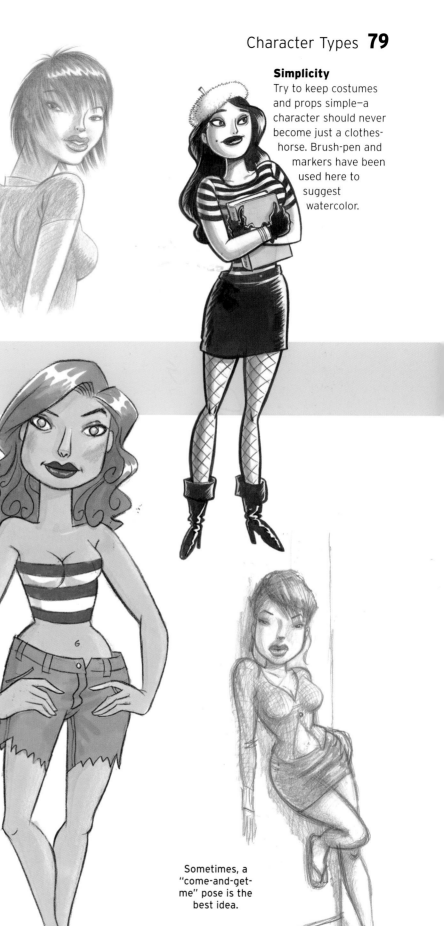

Simplicity
Try to keep costumes and props simple—a character should never become just a clothes-horse. Brush-pen and markers have been used here to suggest watercolor.

The right pose
Find a pose that works for your character. The self-assured, naturalistic posture of this young woman implies her personality better than any "sexy" pose would.

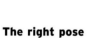

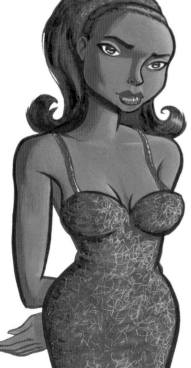

Subtlety
A restrained posture and subtle expression can work well for a character, and may suggest poise and grace.

Sometimes, a "come-and-get-me" pose is the best idea.

Goofballs

The goofball or idiot is probably the most quintessential of all cartoon characters. He is the chump, the sap, the knucklehead, and as Bugs Bunny would say, "the Ultra-Maroon." He is (among others) Dopey, Private Snafu, Ren AND Stimpy, Goofy, Homer Simpson, Elmer Fudd, Smiley Bone, and Sylvester, the mean ol' puddytat. Perhaps we laugh at the idiot because we recognize his idiocy in ourselves.

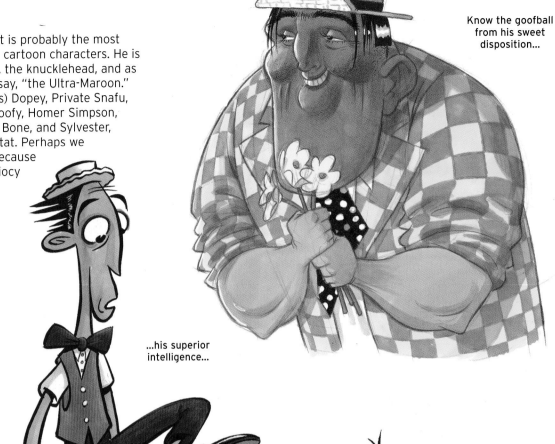

Know the goofball from his sweet disposition...

...his superior intelligence...

...and his sartorial elegance.

"He may look like an idiot and talk like an idiot, but don't let that fool you. He really is an idiot."

Groucho Marx, comedian

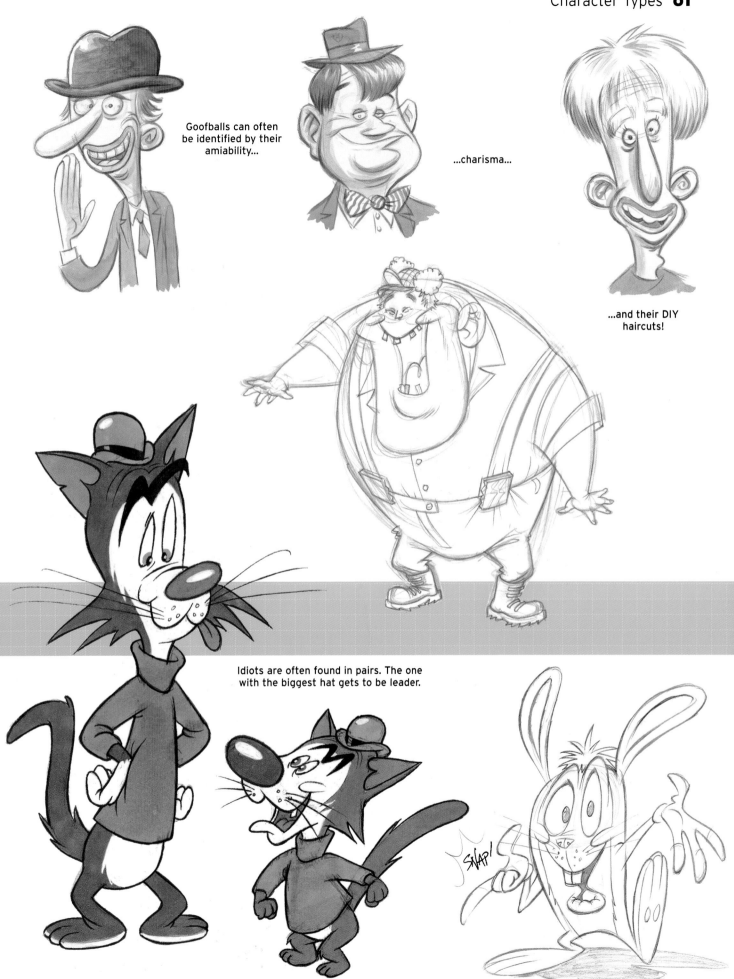

Goofballs can often be identified by their amiability...

...charisma...

...and their DIY haircuts!

Idiots are often found in pairs. The one with the biggest hat gets to be leader.

SNAP!

Comic heroes

The comic hero shares many of the traits of the regular lantern-jawed, shoot-'em-up dramatic hero, but exaggerated to the point of parody. A comic hero will overcome adversity, but just barely—and usually by accident.

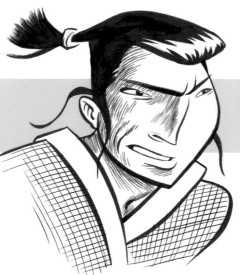

This guy starred in the remake of "Snow White and the Seven Samurai."

Natty outfit, broad shoulders, chiselled features, 1,000-yard stare—this dude's got it all. Except a clue, that is.

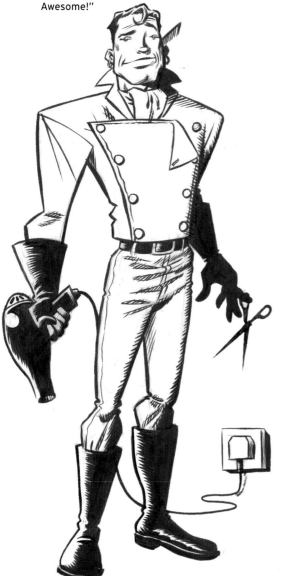

"Hi there! My name's Flash and I'm here to save the world from really bad haircuts. Awesome!"

"The great comic heroes usually reveal foibles rather than heroic strengths."

Chuck Jones, director

By day, Jack Monterey is a billionaire playboy. But at night he becomes The Big Cheese— nemesis to all lactose-intolerant super-criminals.

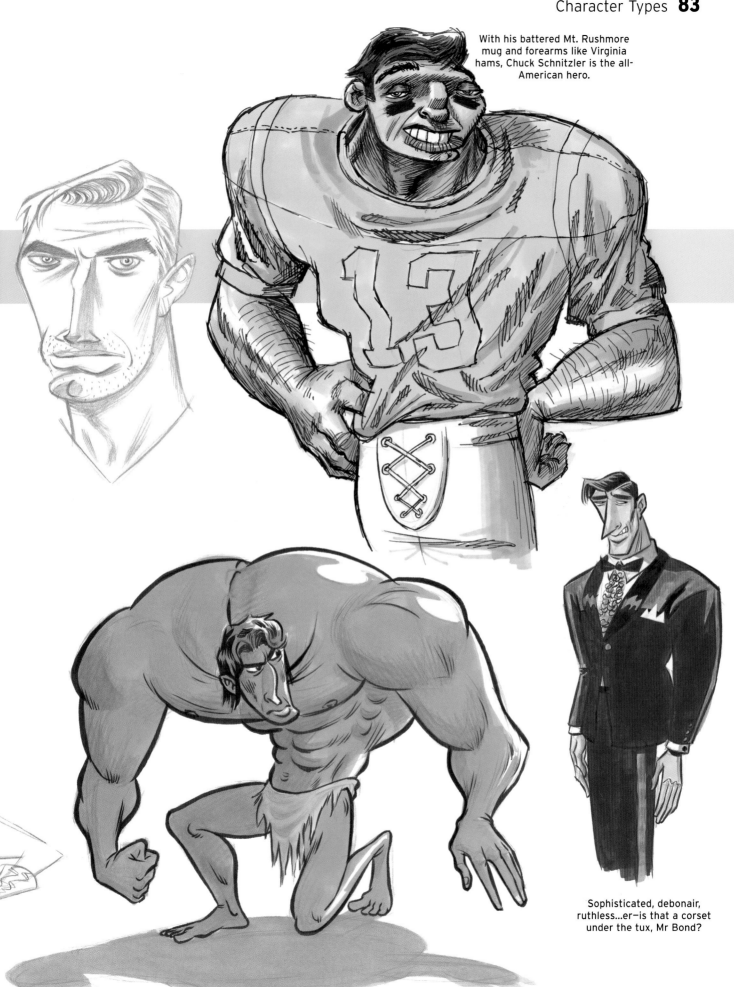

With his battered Mt. Rushmore mug and forearms like Virginia hams, Chuck Schnitzler is the all-American hero.

Sophisticated, debonair, ruthless...er—is that a corset under the tux, Mr Bond?

Villains

As a designer you can really let rip with a villain. Be as colorful with their personality and as over the top as you care to be. Feel free to use lots of angles and pointiness, as these help enhance the sense of danger that they emanate.

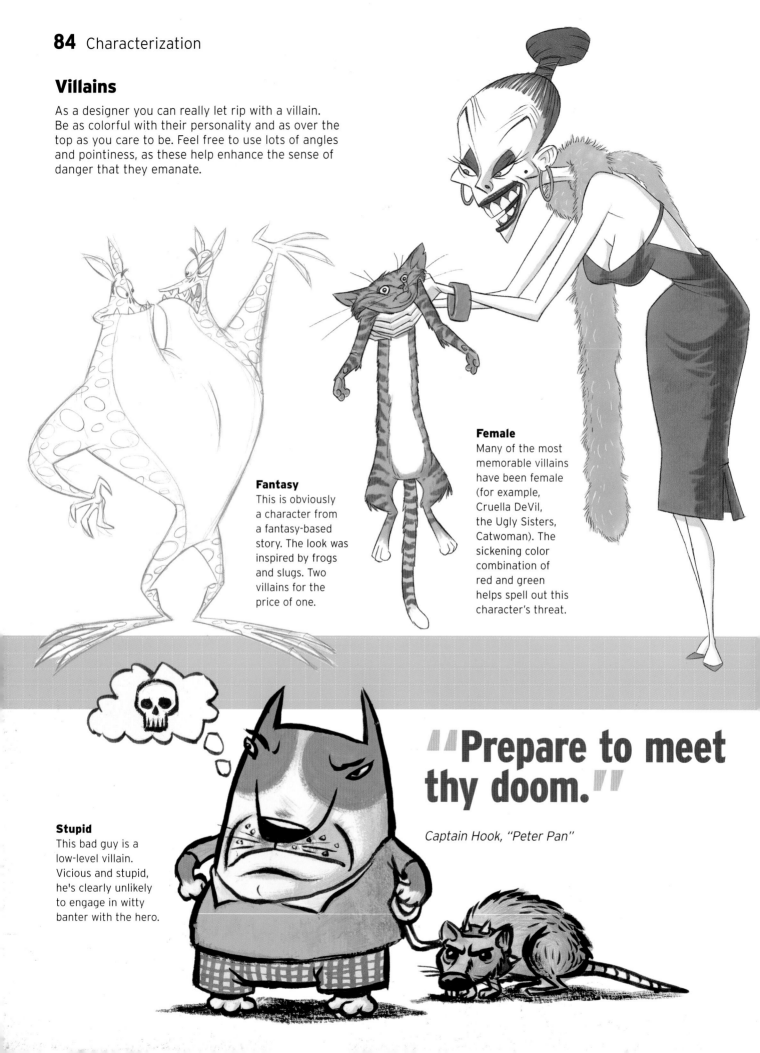

Fantasy
This is obviously a character from a fantasy-based story. The look was inspired by frogs and slugs. Two villains for the price of one.

Female
Many of the most memorable villains have been female (for example, Cruella DeVil, the Ugly Sisters, Catwoman). The sickening color combination of red and green helps spell out this character's threat.

Stupid
This bad guy is a low-level villain. Vicious and stupid, he's clearly unlikely to engage in witty banter with the hero.

"Prepare to meet thy doom."

Captain Hook, "Peter Pan"

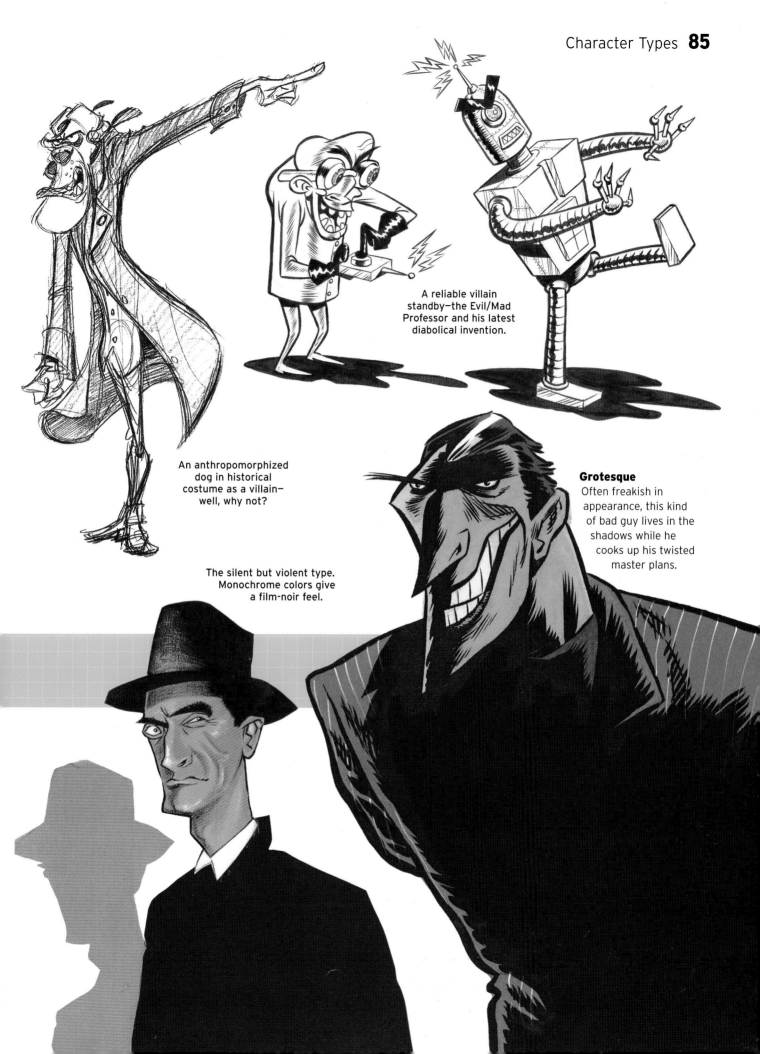

A reliable villain standby—the Evil/Mad Professor and his latest diabolical invention.

An anthropomorphized dog in historical costume as a villain—well, why not?

Grotesque
Often freakish in appearance, this kind of bad guy lives in the shadows while he cooks up his twisted master plans.

The silent but violent type. Monochrome colors give a film-noir feel.

Kids

It really does pay to spend some time studying the way real kids move, talk, and show their emotions. In general, the younger the children, the less self-consciously they behave.

Distinguishing traits

It's always an excellent idea to give your characters different traits and characteristics so that they are easily distinguishable from one another.

Detail

This kid has been drawn with a little too much detail for traditional animation, but the design would work fine in all other contexts.

Clear staging and intent "sell" the design.

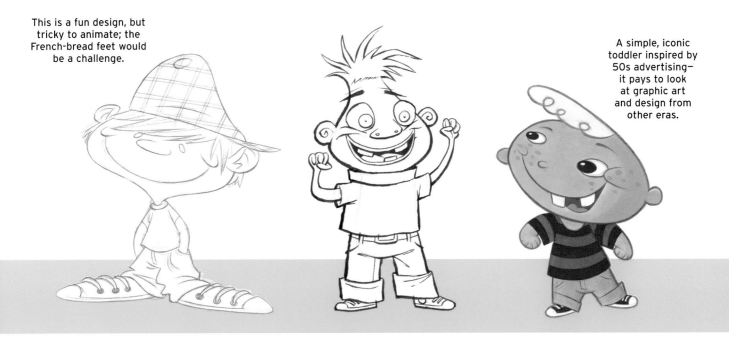

This is a fun design, but tricky to animate; the French-bread feet would be a challenge.

A simple, iconic toddler inspired by 50s advertising— it pays to look at graphic art and design from other eras.

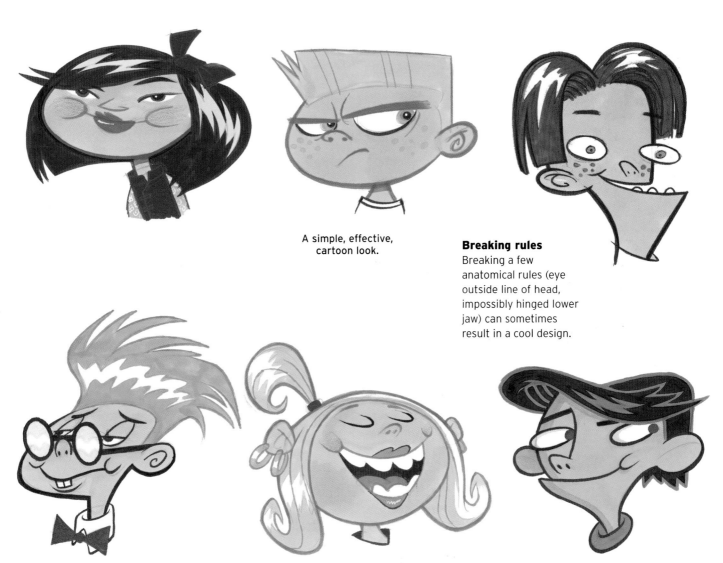

A simple, effective, cartoon look.

Breaking rules
Breaking a few anatomical rules (eye outside line of head, impossibly hinged lower jaw) can sometimes result in a cool design.

"That's a wack 'do, Professor!"

Not cute but memorable.

Teens

Like kids, designing teenagers can be a tough brief. It's very easy to be corny and clichéd, so start sketching from life and concentrate on those telling little details. Don't get too hung up on fashion; these things can change like the wind.

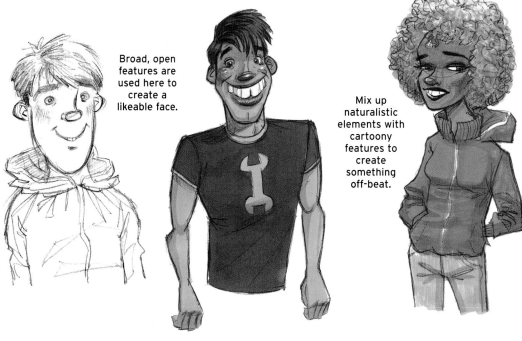

Broad, open features are used here to create a likeable face.

Mix up naturalistic elements with cartoony features to create something off-beat.

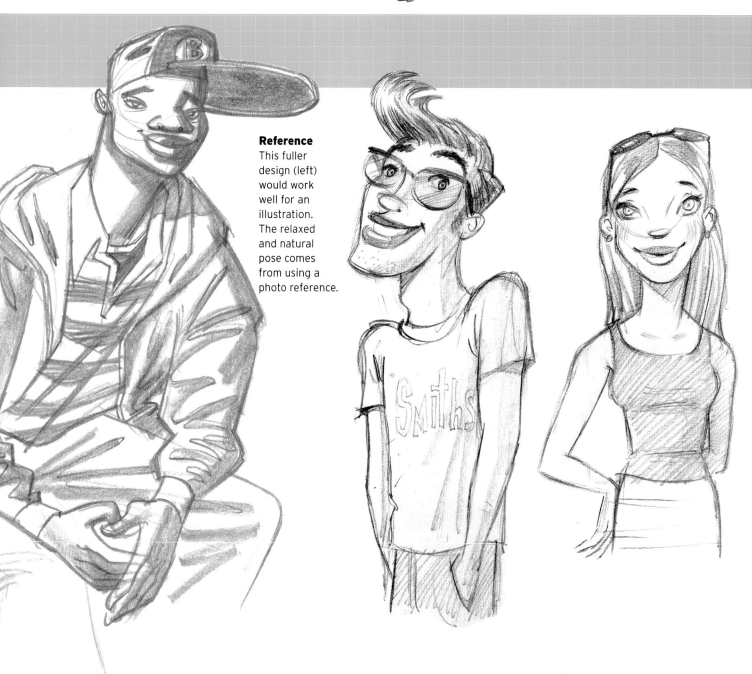

Reference
This fuller design (left) would work well for an illustration. The relaxed and natural pose comes from using a photo reference.

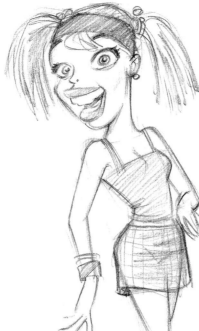

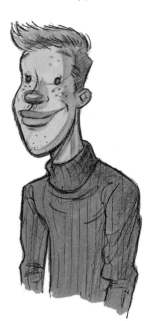

Contrast
This girl's eyes and mouth are exaggeratedly large and childlike to contrast with her more grown-up physique.

Slightly embarrassed smile and rounded shoulders give this character a "Jimmy Stewart" vibe.

Unique touches
Simple graphic design is combined here with realistic touches, such as the posture and the braces, to help make this girl more unique looking.

Animals

The key to making a good character design is knowing your subject.

Cats

The essential idea of a cat is infinitely malleable as these five very different examples testify.

1930s style
This extremely cartoony cat was inspired by 1930s cartoonists such as George Herriman and Cliff Sterrett.

A 1950s-style cartoon cat.

Sitting tabby
Chuck Jones remarked that cats "stand thin and sit fat," as this chunky tabby demonstrates.

Style

In films such as *The Jungle Book* and *The Lion King*, Disney artists have created many wonderful animal characters. But don't feel constrained to work in someone else's style; study and appreciate what's gone before and then do your own thing.

Birds

Birds are tricky to anthropomor...
take time sketching from natur...
photos and then try to distill wh...
observe into your design. Exag...
features that you find interestin...
or amusing and combine huma...
characteristics with a few natu...
details, such as the curve of a...
or the shape of the wings in fli...

...
...
...
are absolute gifts to a
cartoonist. Their natural
color schemes adapt
beautifully to graphic
designs, even simplistic
ones such as this one.

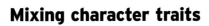

Mixing character traits

You can give your characters unusual personality traits—the cow above thinks she's a cat!

Anthropomorphism

There are no rules to say how far or
how little you should humanize an animal
character. The tortoise on this page is a
restrained and simple design that remains
close to its real-life inspiration, while the designs
of other characters on these pages sacrifice
naturalism for personality. Don't get too hung
up on your drawing style or technique—let your
hand be guided by the imagined personality
of the character you are designing.

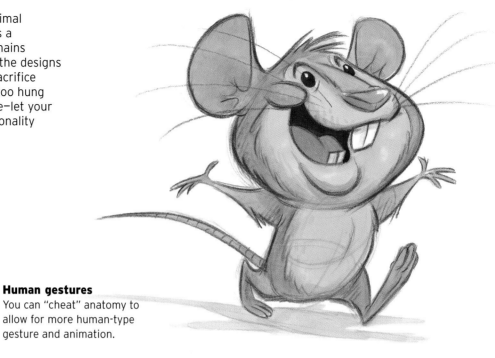

Human gestures
You can "cheat" anatomy to
allow for more human-type
gesture and animation.

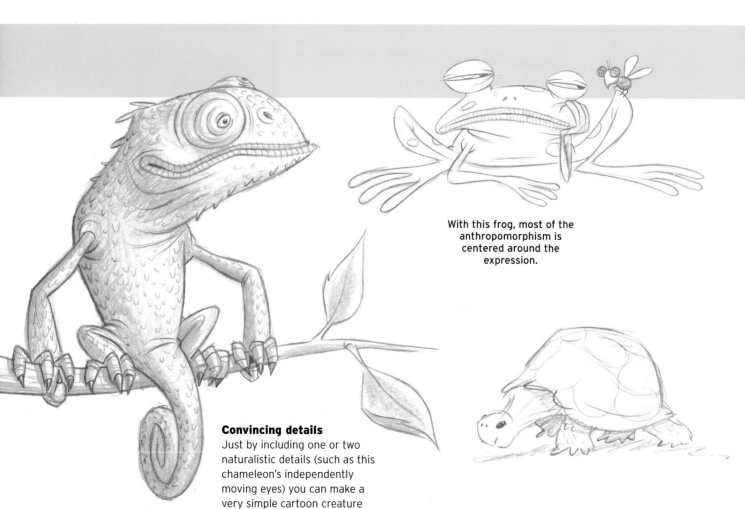

With this frog, most of the
anthropomorphism is
centered around the
expression.

Convincing details
Just by including one or two
naturalistic details (such as this
chameleon's independently
moving eyes) you can make a
very simple cartoon creature
convincing to a viewer.

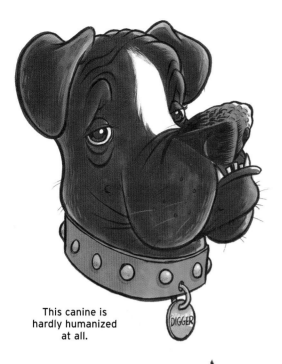

This canine is
hardly humanized
at all.

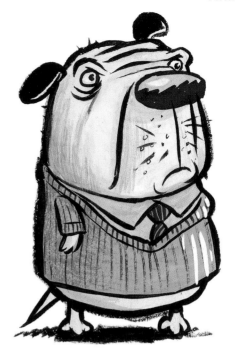

Try to retain at least a little of the
original animal's physicality.

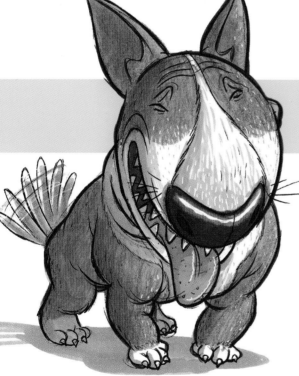

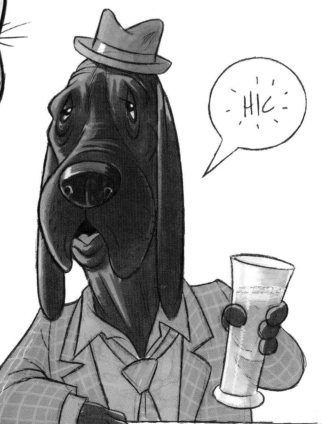

HIC

Essential characteristics
Pay attention particularly to overall
skull shapes and the relationships of
the facial features with each other.
Both these examples exaggerate the
breeds' characteristics but remain
true to what distinguishes one breed
from another.

Contextualization

It's always a much, much better idea to put your characters into an implied context than to simply draw them standing stock-still and lifeless in a complete void. You should want your characters to be interesting; to be engaging. Draw the viewer into their world by suggesting that they have emotions, thoughts, and reactions. Don't just rely on your scintillating draftsmanship to impress the viewer—make them ask questions of the characters.

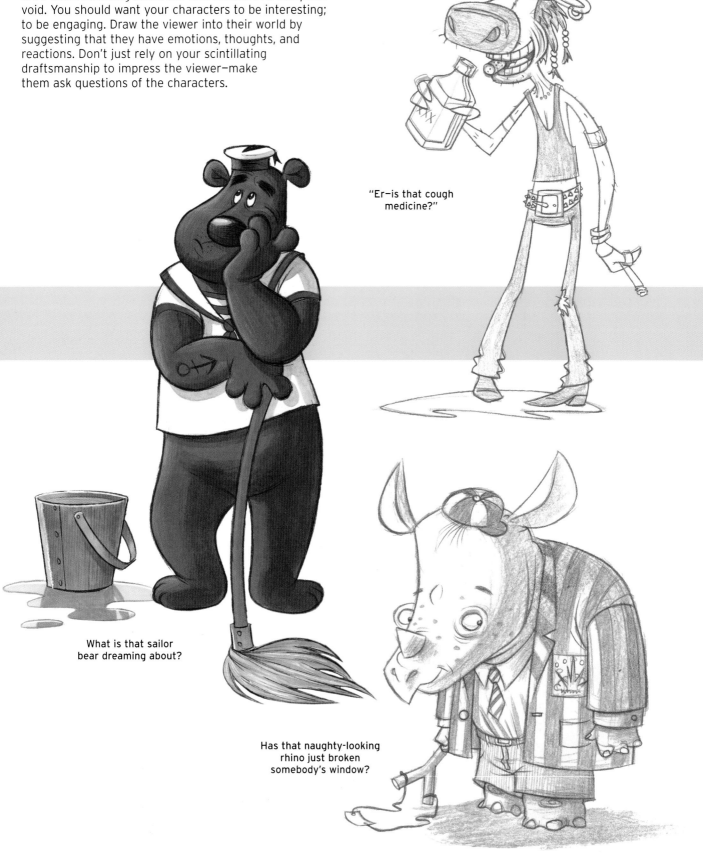

"Er—is that cough medicine?"

What is that sailor bear dreaming about?

Has that naughty-looking rhino just broken somebody's window?

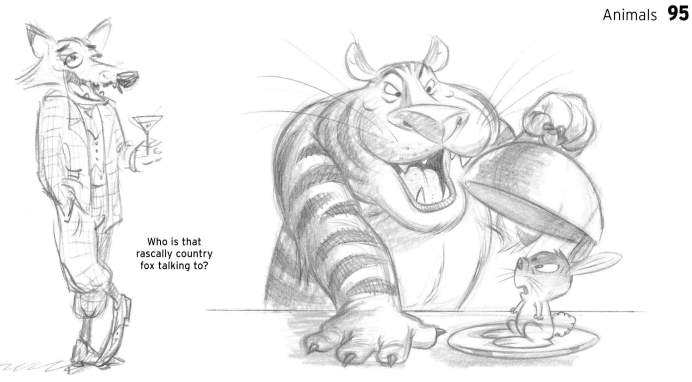

Who is that rascally country fox talking to?

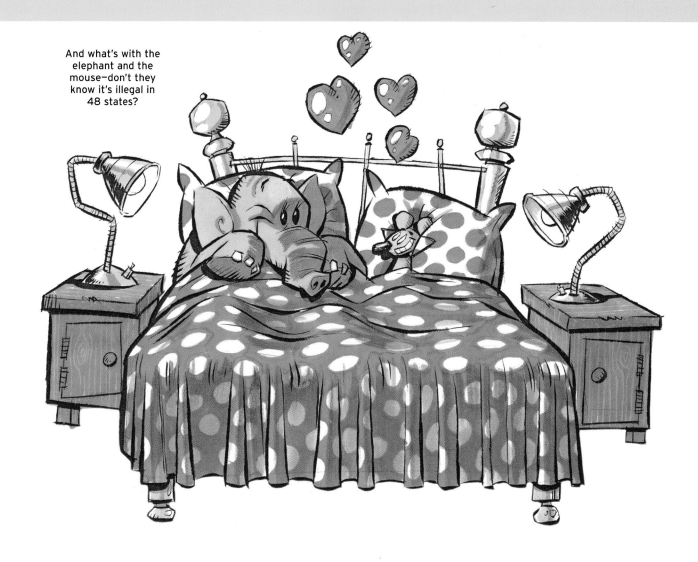

And what's with the elephant and the mouse—don't they know it's illegal in 48 states?

The shadow grounds this character.

Shadows

A simple, puddle-like shadow can anchor your characters to a "ground," even if they appear on white, or it can help "lift" characters in a leap or jump pose. A more naturalistic shadow can give a little more information on form.

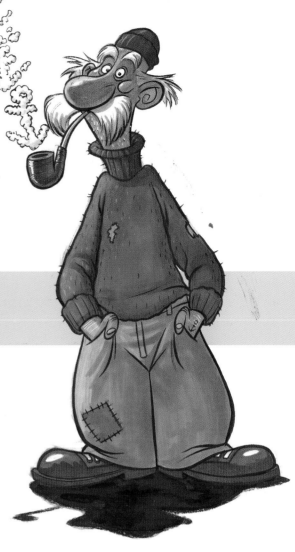

Lighting

Selective use of lighting effects can enhance your character design and lend drama, volume, and a believable connectedness with an environment or background. Even the flattest, most graphically designed character can look at least two-and-a-half dimensional with a ground shadow and a little tonal work.

There are three basic tonal divisions to suggest the play of light and shadow on a rounded form. The first is the "true" or "natural" color of the surface of an object or character as seen in ambient or reflected light. The second is the "highlight" color of that same object or character as it is illuminated by a direct light-source, such as the sun or a spotlight. This color is a more radiant and intense version of the "true" color. Shadow tone is the third type of tone. This is a darker hue of the "true" color. Create this tone by adding violet, blue, black or gray, possibly with the addition of the complementary color to the natural color.

Tone and texture

This sailor has all three divisions of tone; the edges between them have been softened. Texture has been added to his sweater by picking out a few flecks with a white roller pen over the marker color. Red pencil rendering was added to the nose and cheek.

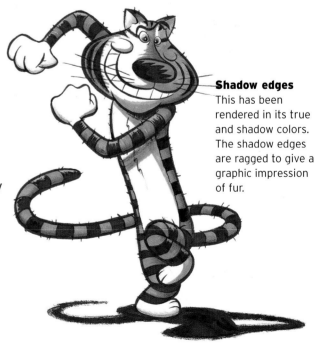

Shadow edges
This has been rendered in its true and shadow colors. The shadow edges are ragged to give a graphic impression of fur.

True colors
This character has only the "true" colors– there are no highlights or shadow tones.

Directional light

You can use directional light for a more sophisticated or dramatic treatment of a character. You can also use it to suggest locale and mood.

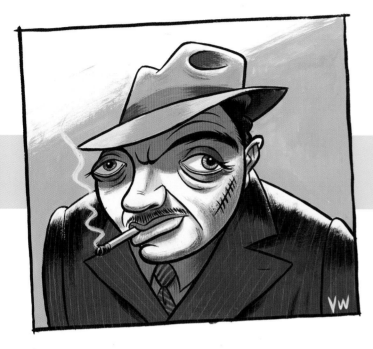

Top lighting
With a strong overhead light, shadows are cast underneath forms—for example, under the brim of the hat, nose, and mouth. Chiaroscuro was dry-brushed between the highlight and natural tones to dramatize the lighting.

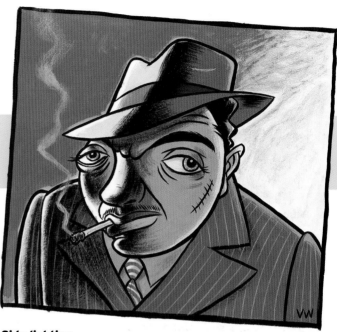

Side lighting
This type of lighting produces a "softer" look to a character and helps to emphasize the features.

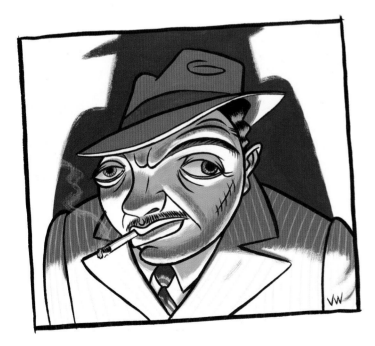

Bottom lighting
Useful for an atmospheric *film noir* feel to a design or illustration. Will make most faces look creepy or threatening.

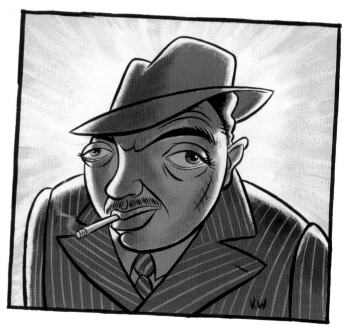

Back lighting
This kind of lighting adds a little mystery to a character, as almost all of the features are obscured within the shadow area. There are no cast shadows as such, only a rim-light effect.

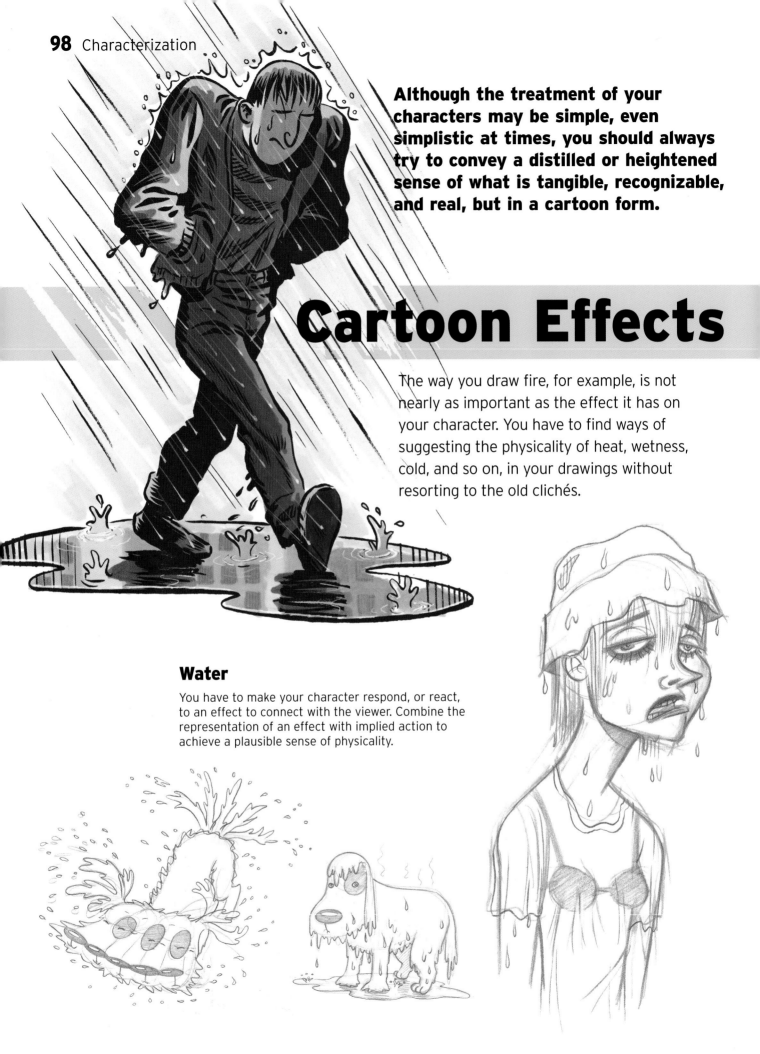

Although the treatment of your characters may be simple, even simplistic at times, you should always try to convey a distilled or heightened sense of what is tangible, recognizable, and real, but in a cartoon form.

Cartoon Effects

The way you draw fire, for example, is not nearly as important as the effect it has on your character. You have to find ways of suggesting the physicality of heat, wetness, cold, and so on, in your drawings without resorting to the old clichés.

Water

You have to make your character respond, or react, to an effect to connect with the viewer. Combine the representation of an effect with implied action to achieve a plausible sense of physicality.

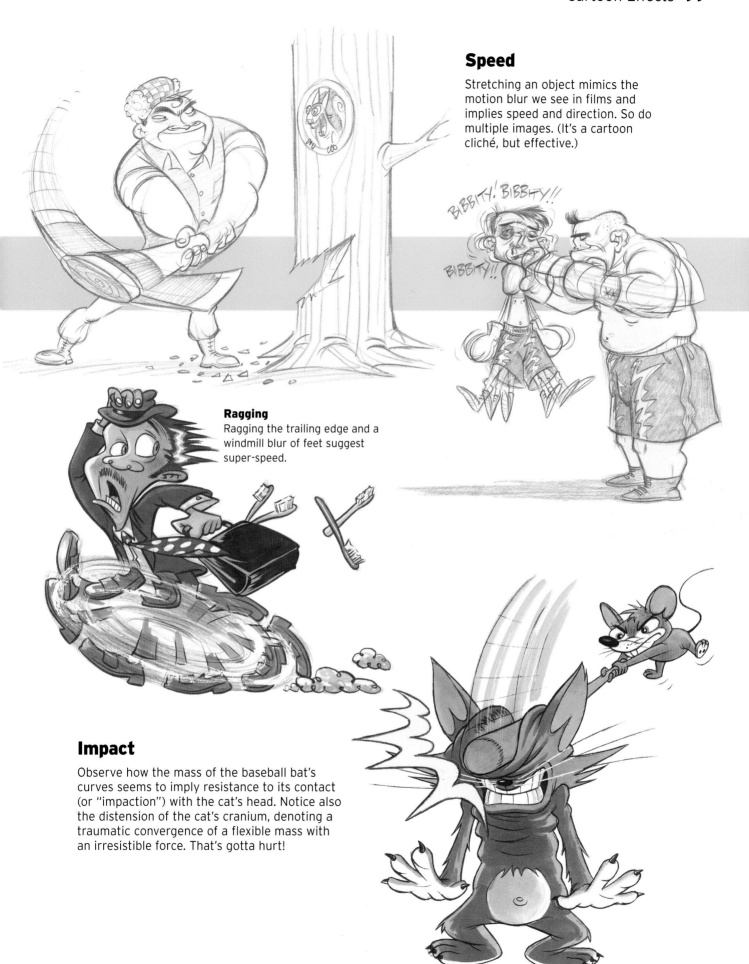

Speed

Stretching an object mimics the motion blur we see in films and implies speed and direction. So do multiple images. (It's a cartoon cliché, but effective.)

BIBBITY! BIBBITY!!

BIBBITY!!

Ragging

Ragging the trailing edge and a windmill blur of feet suggest super-speed.

Impact

Observe how the mass of the baseball bat's curves seems to imply resistance to its contact (or "impaction") with the cat's head. Notice also the distension of the cat's cranium, denoting a traumatic convergence of a flexible mass with an irresistible force. That's gotta hurt!

Wind

The swirls in the picture on the right are supposed to represent wind, but the character looks completely untouched. It would be so much better to show him struggling to stay upright. Billowing or "ragging" the edges of clothing on one side of a character implies the speed and direction of the wind, while his posture confirms the effects of the wind's action.

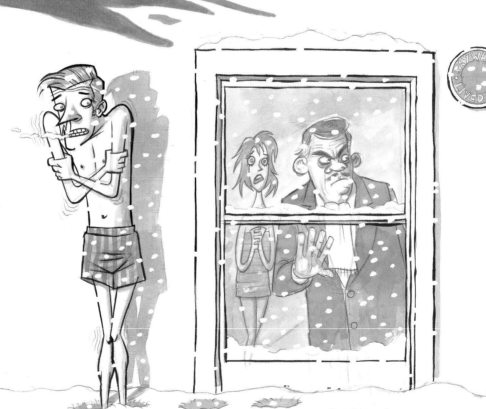

Cold

You know that this character is cold because of the snow, ice, and breath, but mainly because of his attitude. Notice that the "snow" is only visible against the characters.

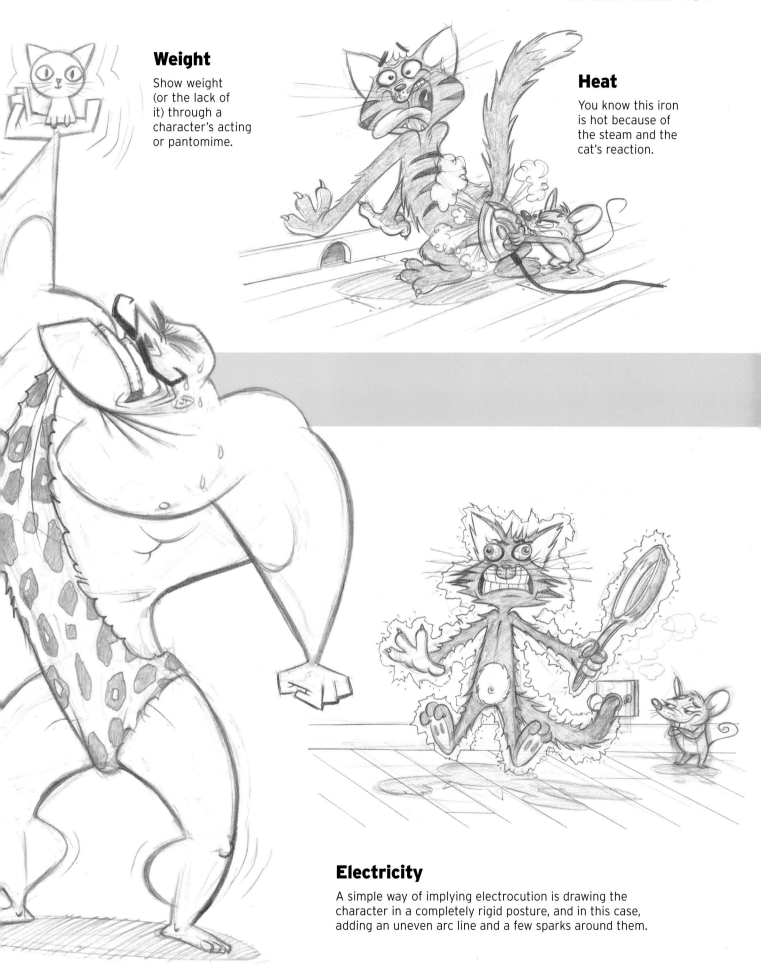

Weight

Show weight (or the lack of it) through a character's acting or pantomime.

Heat

You know this iron is hot because of the steam and the cat's reaction.

Electricity

A simple way of implying electrocution is drawing the character in a completely rigid posture, and in this case, adding an uneven arc line and a few sparks around them.

When designing props to be used by and in conjunction with your characters, consider style, functionality, and essence.

Style

The graphic style of both your props and your characters should be consistent. If your characters are drawn in a "realistic" style, giving them zany cartoon props may look visually jarring.

Props

Functionality

Does the prop look as if it could really function? Will the various parts of the prop that need to be handled/sat on/worn by a character be compatible with his scale and anatomy?

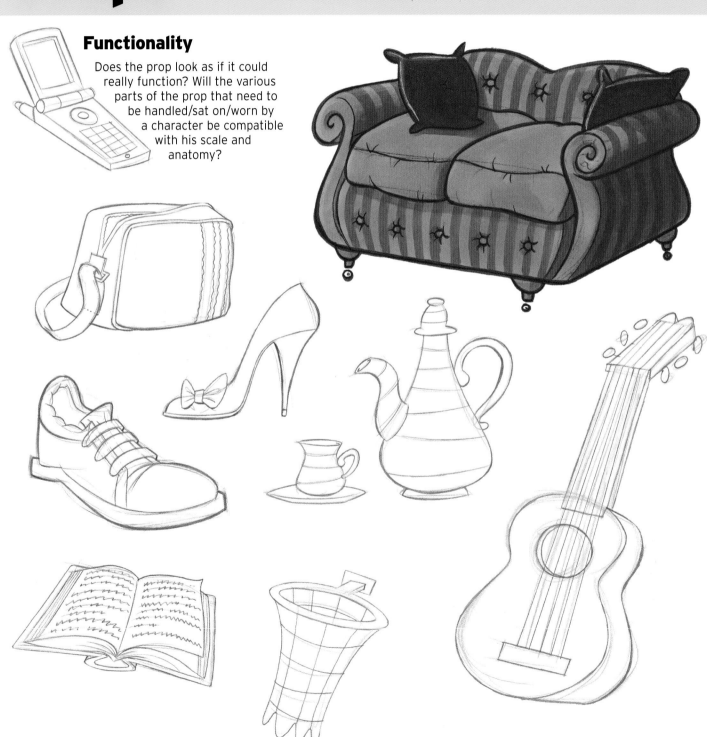

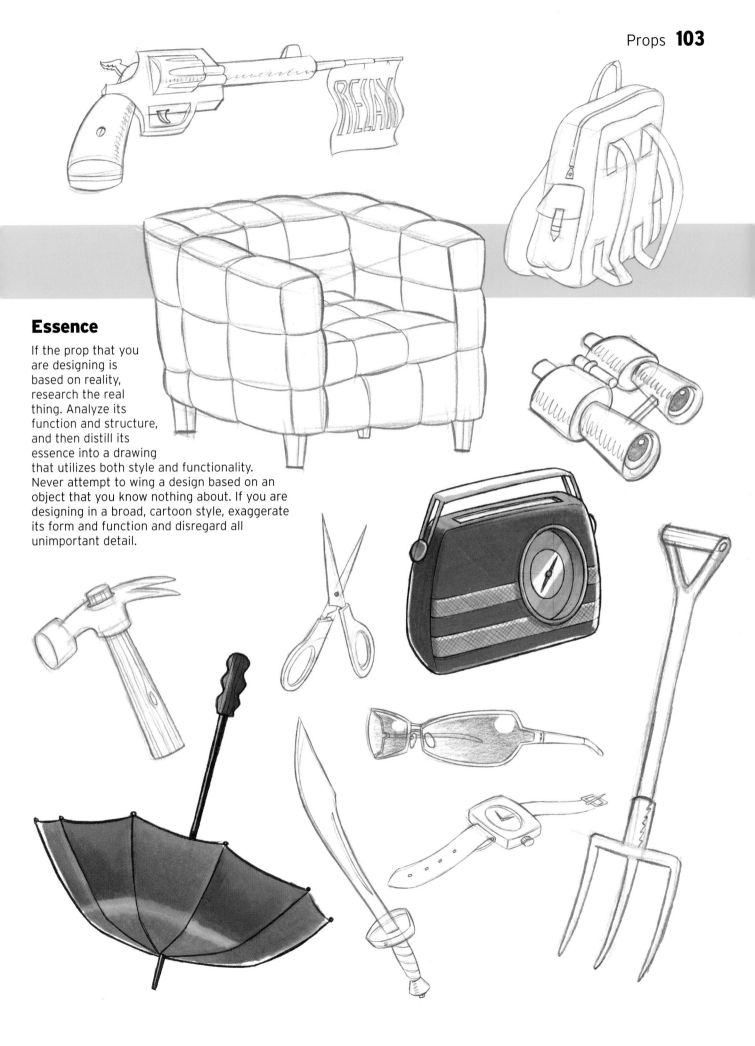

Essence

If the prop that you are designing is based on reality, research the real thing. Analyze its function and structure, and then distill its essence into a drawing that utilizes both style and functionality. Never attempt to wing a design based on an object that you know nothing about. If you are designing in a broad, cartoon style, exaggerate its form and function and disregard all unimportant detail.

Professional Practices

No matter what the medium—comics, illustration, animation, web-design, packaging, or licensing—the practices and working methods of character design remain more or less the same. Of all these applications though, it's animation that requires the most information in a design. Not only must you determine the exact look of an animated character, but you also have to imply potential personality and movement. This chapter details some important aspects of producing designs for animation, as well as giving valuable insights into the way three professional artists work.

Model Sheets

Comic books, newspaper strips, and animated films are rarely produced by just one artist. The model sheet was developed so that many artists can draw a character with uniform proportions and attitudes. In traditional feature animation, the characters' lead animator develops or refines the initial designs. The final model sheet is a paste-up of the best poses.

Time and money constraints make this second-stage refinement something of a rarity these days, putting extra pressure on the designer to come up with a character that can go straight into production. A good example of a model sheet would contain a variety of attitudes, gestures, and implied movement and personality.

The examples on these two pages show typical model sheets.

This sheet details the character's head as a supplement to the regular model sheet.

Expression sheets

A central character in a series or feature may also have their own expression sheet, again to help in achieving consistency of design, attitude, and personality no matter who animates them.

Two expression sheets for characters from the same show.

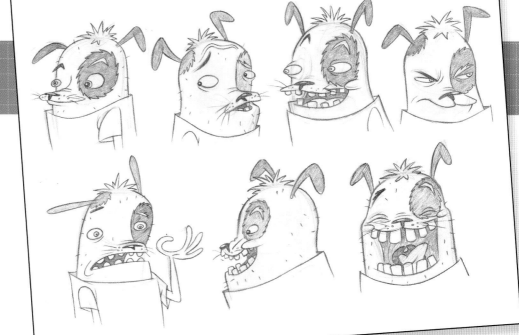

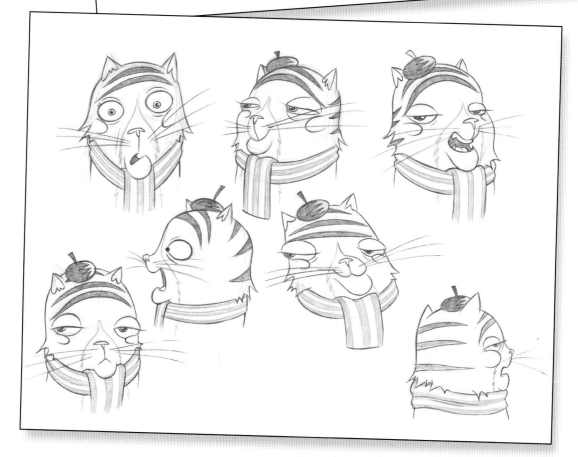

Turnarounds

The turnaround (or "spin" as it's sometimes known) is the self-explanatory term given to a series of drawings that usually shows five aspects of a character in the same pose, as seen from the same point of perspective.

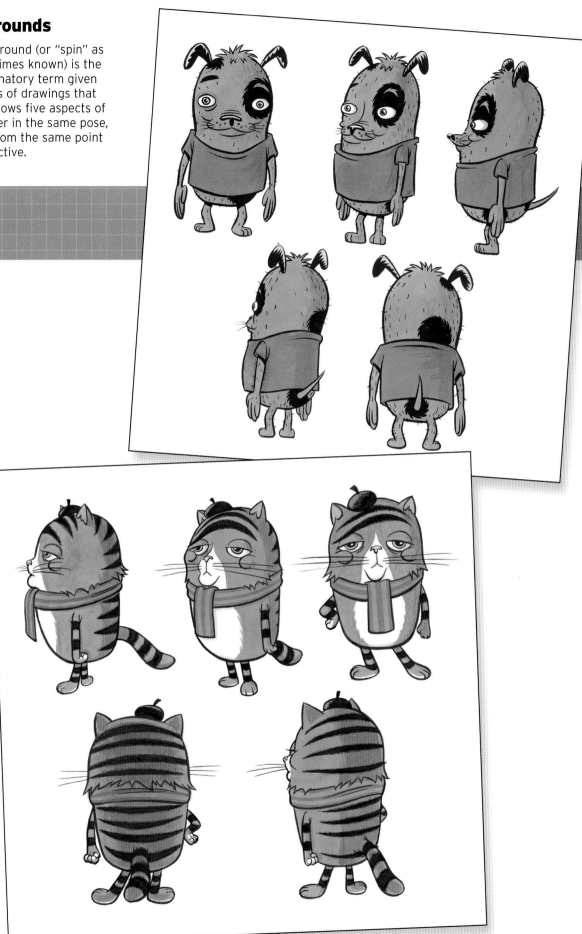

Character designs are everywhere: on packaging, on television and the Internet, in comic books and graphic novels, at the movies, in illustrated books, in toy stores, even on clothing. The best of these designs—the characters with the most vivid appeal— are often conceived for animation of one form or another.

From Script to Screen

In nearly every example, no matter what the medium, memorable characters originate in the time-honored form of handmade drawings. More than any other form of character, the animated personality—when uniquely designed, dexterously animated, and entertainingly voiced—can make the most universal impact on an audience. For this reason, this entire chapter is devoted to designing for different aspects of animation rather than for any other application.

Design approach

The following pages focus on the work of three top professional animators. They discuss their approach to the craft and show how they design a new character from scratch.

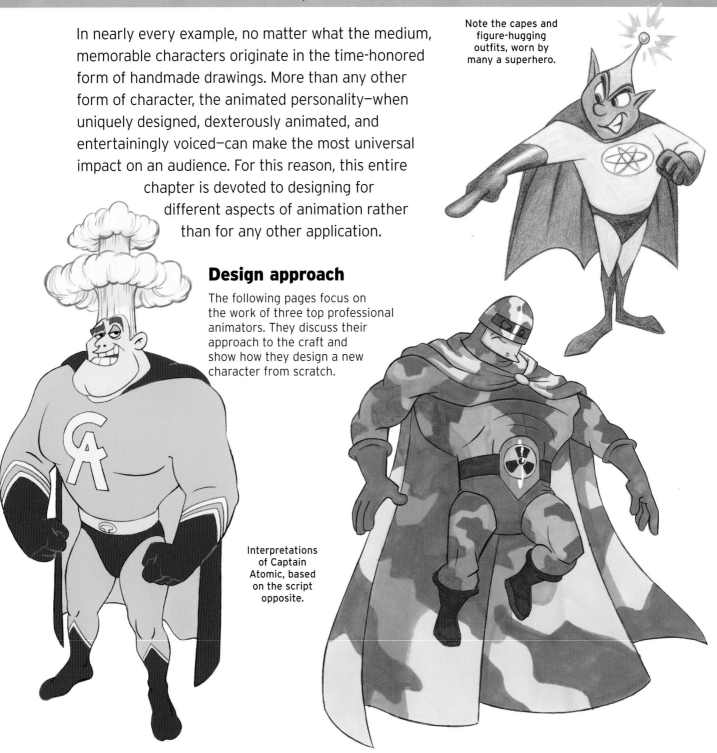

Note the capes and figure-hugging outfits, worn by many a superhero.

Interpretations of Captain Atomic, based on the script opposite.

Spoof script

We gave all the artists this same spoof script for a fictitious breakfast cereal. See how each interpreted it over the page.

Script for SUGAR NUKES 30-second TV commercial

MUSIC: Grieg's funeral march.
PICTURE: Black & white. A dreary, gothic dining hall reminiscent of Charles Addams or Edward Gorey. The camera trucks in to three miserable kids (WILLY, BILLY, and MILLY) dressed in stiff, starchy Victorian clothes and sitting at a mile-long dinner table. In front of the kids are three plates with silver covers.

MEDIUM SHOT: In quick succession the three children remove the covers to reveal a stinky-looking kipper on each of their plates.

WILLY
Yuck!

BILLY
Bleurgh!

MILLY
Ee-u!

MUSIC: Ride of the Valkyries.
SOUND: Dropping-bomb-type whistle, followed by a BOOM!
PICTURE: A muscle-bound superhero appears in a mushroom cloud.

WILLY, BILLY, & MILLY
Wow! Captain Atomic!

CAPT. ATOMIC
(grinning cheesily)
Having a bad HAIR-ing day?

BILLY
Yeah. This sucks!

CAPTAIN ATOMIC whisks away the tablecloth, kippers and all. He then whips the camouflage cape from his shoulders and spreads it on the table in front of the kids with a magician's flourish revealing a SUGAR NUKES pack, a jug of milk, and three bowls and spoons. [N.B. As he whips his cape through the air, a magical rainbow passes over the entire picture changing everything from B&W to color, and transforming the kids' clothes into modern garb.]

CAPT. ATOMIC
Try some Sugar Nukes!

WILLY, BILLY, & MILLY
Yay!!

CLOSE-UP: Milly pours milk over her Sugar Nukes. They start to fizzle, so she leans in close to listen. One or two detonate in tiny explosions making little mushroom clouds.

CAPT. ATOMIC (voice-over)
Sugar Nukes! Bomb-shaped clusters of uranium-enriched goodness!

WIDE SHOT: All three kids happily eating their Sugar Nukes. Suddenly, explosions go off in their mouths and they shoot up out of screen, only to float back on parachutes a few seconds later looking happily shell-shocked.

CLOSE-UP: Captain Atomic is holding up a Sugar Nukes pack to camera.

CAPTAIN ATOMIC
Kids! Don't be mooks—eat Sugar Nukes!!

PULL OUT: to reveal BILLY, WILLY, & MILLY seated in front of the Captain.

BILLY, WILLY, & MILLY
(dazed and grinning)
Thanks Captain!

PICTURE: As they speak, some of their teeth fall out. All three kids are glowing green. Milly and Willy have lost some hair, Billy's arm drops off.

CLOSE-UP: Pack shot.

JINGLE
"When breakfast time's Enola Gray,
turn sirens on, yell 'Bombs Away!'
with SU-GAR NUKES!"

Philip Vallentin

An animation graduate from Ontario's prestigious Sheridan College, Philip Vallentin founded and runs Espresso Animation—where he works as producer, director, and designer. Philip usually starts the coloring early on with a design, scanning his drawings and then using graphics software to manipulate them. Phil's design philosophy is a simple one: if he can sincerely believe in a design, then he hopes that the audience will.

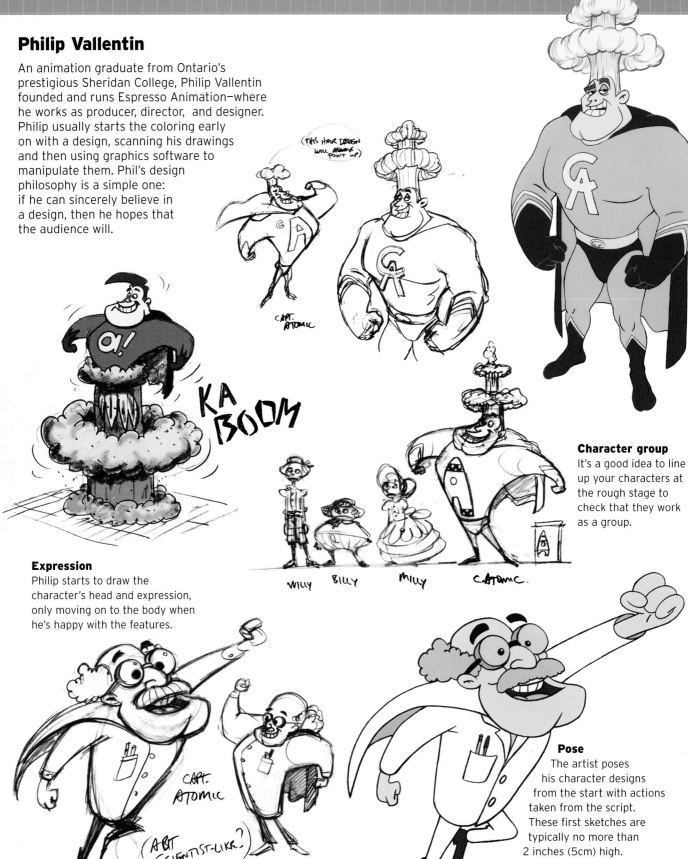

Character group
It's a good idea to line up your characters at the rough stage to check that they work as a group.

Expression
Philip starts to draw the character's head and expression, only moving on to the body when he's happy with the features.

Pose
The artist poses his character designs from the start with actions taken from the script. These first sketches are typically no more than 2 inches (5cm) high.

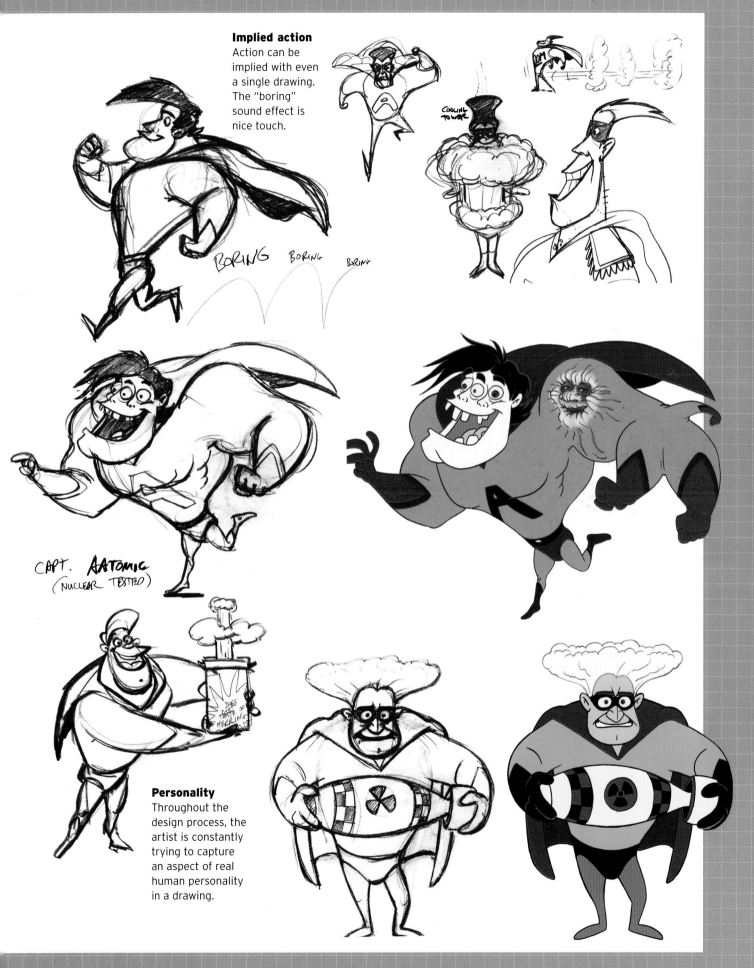

Implied action
Action can be implied with even a single drawing. The "boring" sound effect is nice touch.

BORING BORING BORING

COOLING TO WOR

CAPT. AATOMIC
(NUCLEAR TESTED)

DOES A NOTE OF HERRING

Personality
Throughout the design process, the artist is constantly trying to capture an aspect of real human personality in a drawing.

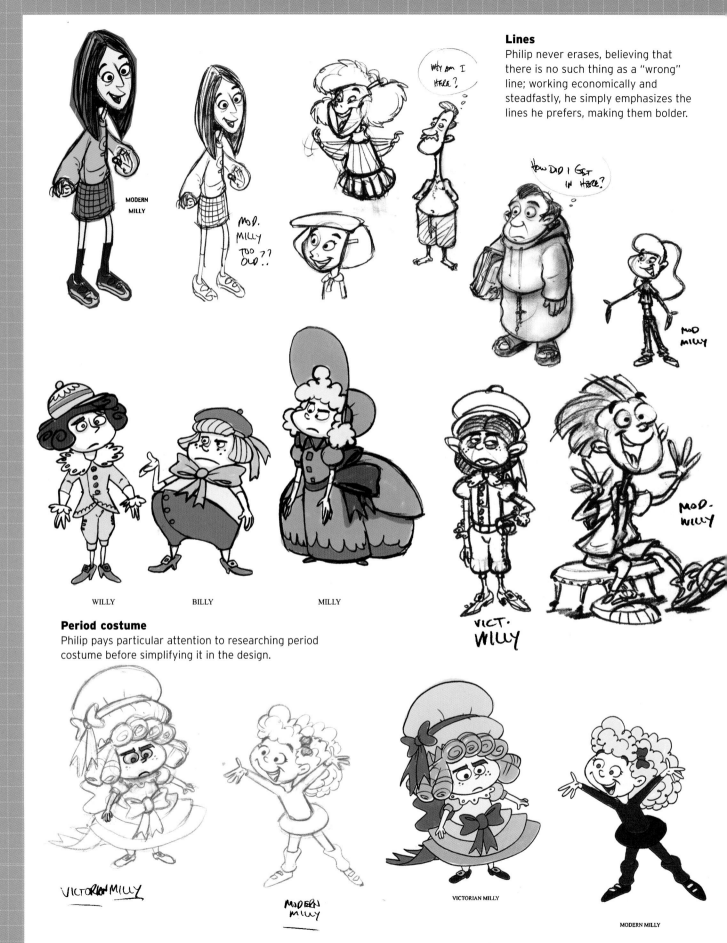

Lines
Philip never erases, believing that there is no such thing as a "wrong" line; working economically and steadfastly, he simply emphasizes the lines he prefers, making them bolder.

MODERN MILLY

MOD. MILLY TOO OLD??

WHY AM I HERE?

HOW DID I GET IN HERE?

MOD MILLY

WILLY

BILLY

MILLY

VICT. WILLY

MOD. WILLY

Period costume
Philip pays particular attention to researching period costume before simplifying it in the design.

VICTORIAN MILLY

MODERN MILLY

VICTORIAN MILLY

MODERN MILLY

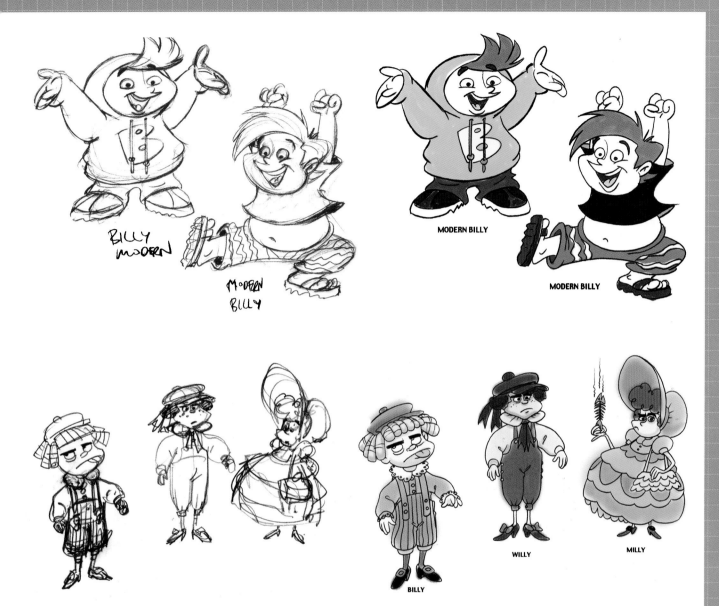

BILLY MODERN

MODERN BILLY

MODERN BILLY

MODERN BILLY

BILLY

WILLY

MILLY

Working together

It pays to consider central characters as a unit when designing to ensure that there is enough difference between them to make them recognizable and yet harmonious when seen together.

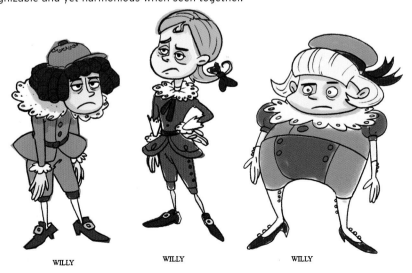

WILLY

WILLY

WILLY

Clarity

Philip allows his characters' design and personalities to emerge through careful staging and absolute clarity in his posing, constantly asking questions such as "Is this character sarcastic? Or self-important? How would they express themselves?" and so on.

Teddy Hall

Teddy Hall began his career at the Halas and Batchelor studio before moving to Richard Williams Animation. He stayed there for 8 years, studying with Dick Williams as well as Art Babbitt, Ken Harris, and Eric Goldberg. After a stint as an animator on Disney's *Hercules*, Teddy now works as an animator and designer, as well as a model-maker, producing maquettes for animated projects.

Before starting to design, Teddy browses through books of cartoons, fine art, design, and photos to stimulate ideas. He makes brief notes, accompanied by thumbnails, and then starts to draw spontaneously, trying to find interesting shapes for heads and figures.

Although reluctant to list them in any order, Teddy admits that Mary Blair, Freddy Moore, Chuck Jones, and Ronald Searle have influenced his work.

Finding a character
For these characters Teddy looked at studies of children by Norman Rockwell. He combined the best parts of different drawings, until a character began to work.

Having "found" the characters, the artist concentrated on the period costume design.

Attitude and personality

Teddy refines the shapes, volumes, and the implied attitude and personality of each character design, pushing it toward a cartoon animation style.

Any one of the designs on these pages, with their clean and appealing shapes, would be suitable for animation.

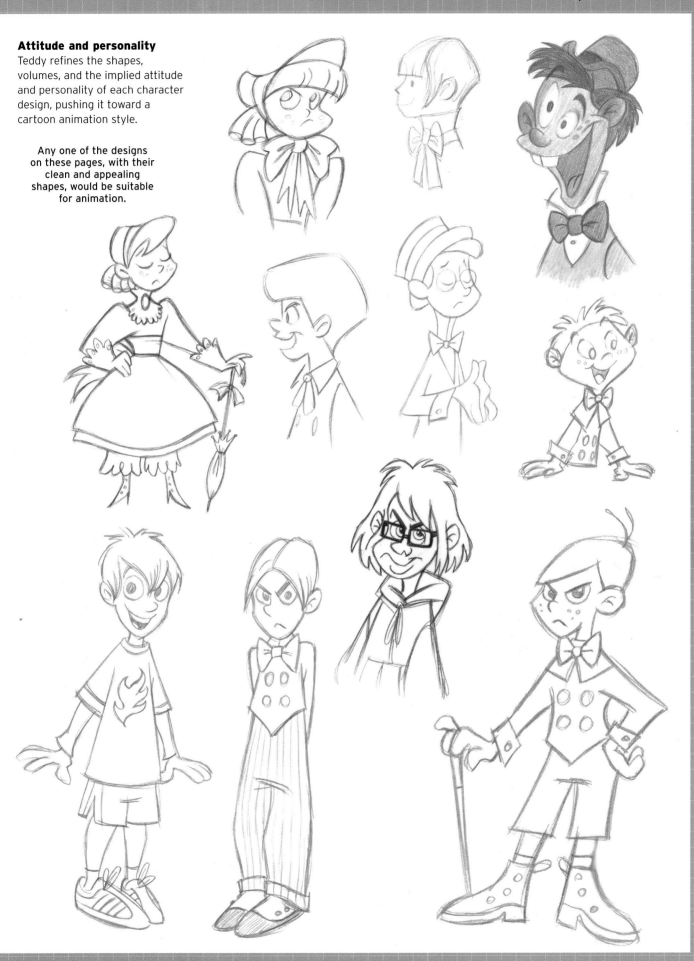

Captain Atomic

Having come up with the designs for the children, Teddy experimented with Captain Atomic's look.

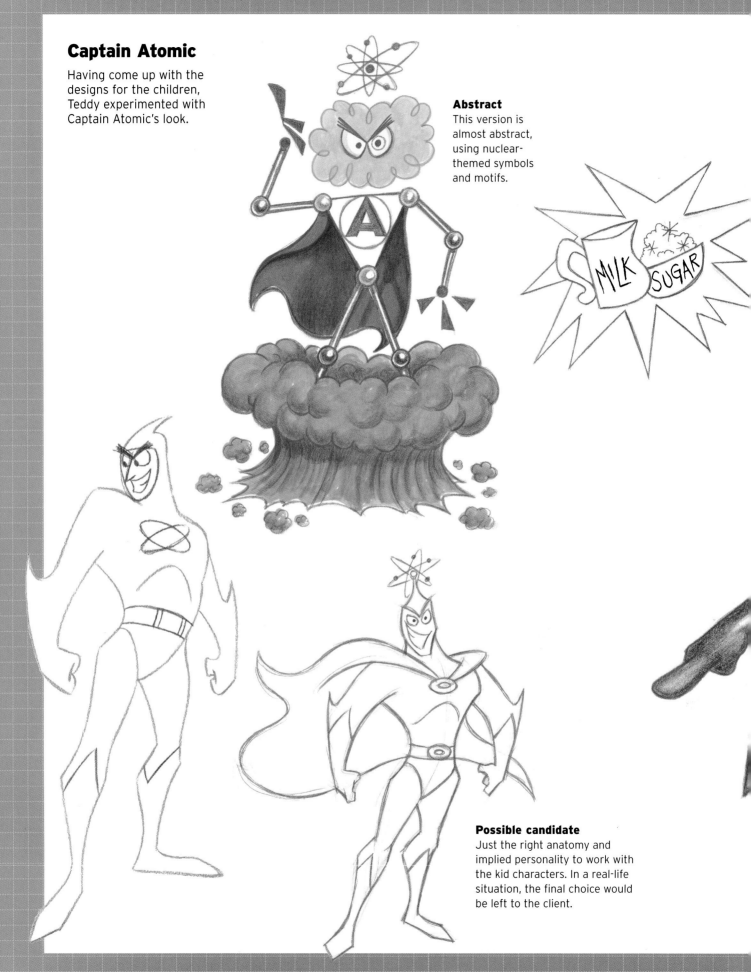

Abstract
This version is almost abstract, using nuclear-themed symbols and motifs.

Possible candidate
Just the right anatomy and implied personality to work with the kid characters. In a real-life situation, the final choice would be left to the client.

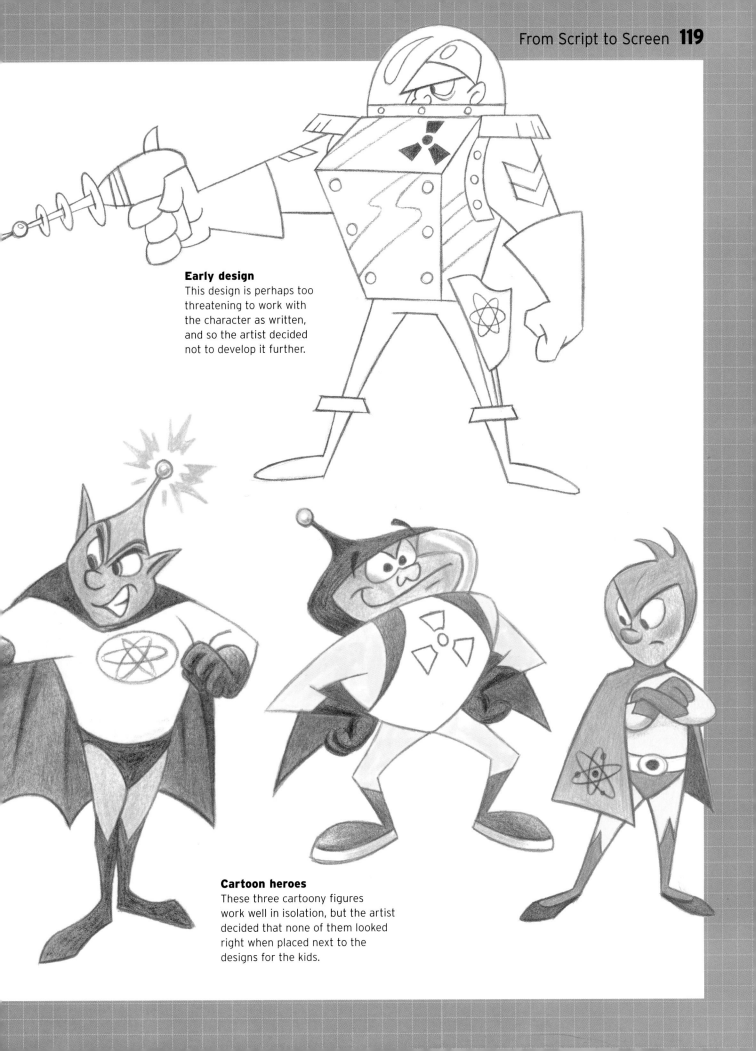

Early design
This design is perhaps too threatening to work with the character as written, and so the artist decided not to develop it further.

Cartoon heroes
These three cartoony figures work well in isolation, but the artist decided that none of them looked right when placed next to the designs for the kids.

Clive Pallant

After graduating with a degree in animation, Clive worked at a number of studios in London before joining Richard Williams Animation, where he subsequently became an animator-director of TV commercials. Not only has Clive run his own studio, but he's also directed and animated for Walt Disney and Warner Bros. (*Jungle Book II* and *Space Jam*) as well as many of the top animation companies in the U.K. and Europe. He lives in Spain with his wife and two cats.

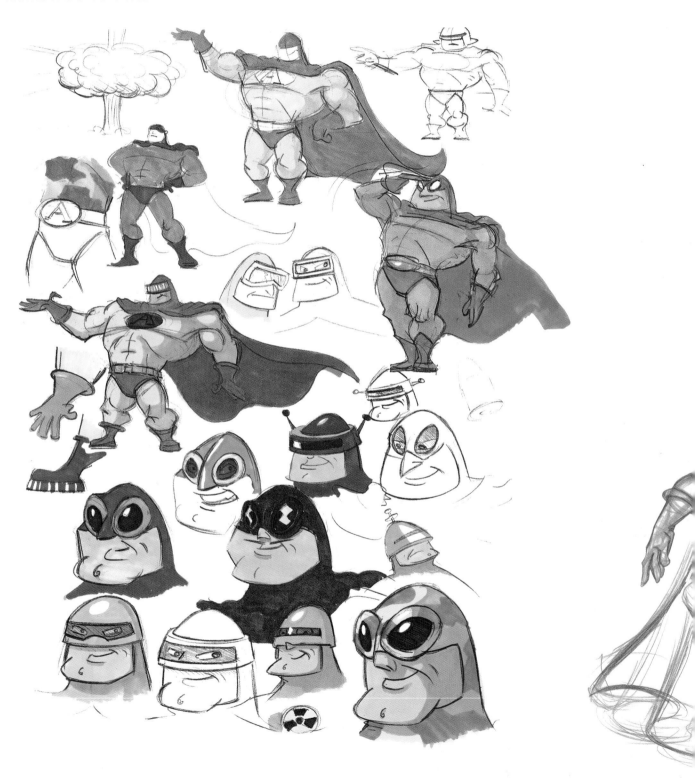

Working methods

For Clive, the design always starts with the script, which he will study looking out for any "must have" or visually suggestive points.

When designing for animation, Clive aims to first visualize a 3-D form in his head that he then tries to capture in his drawing. He aims for simple but interesting characters and eliminates excess detail as he goes. His first sketches are doodles which he then allows to take shape in a loose and spontaneous way. Having completed several sheets of initial designs, he will leave them for a day or two before returning with a fresh eye. He then makes larger, rough drawings based on the thumbnails he likes best. At this point he will check for bad anatomy, sometimes by looking at the drawing in a mirror.

The last stage is to place the roughs on a backlight and re-draw in a pale colored pencil, making any final changes. The final clean-up is then photocopied and marker colors added.

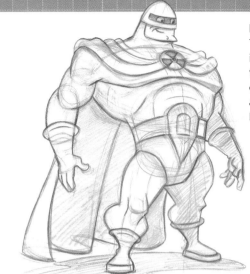

Humor
Too-short legs in proportion to the torso add humor and edge the character away from comic book clichés.

Cloak and goggles
The cloak appears in the script. The protective goggles were added to fit with the radiation theme.

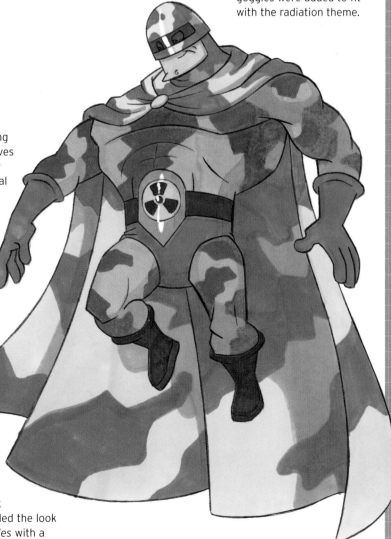

Camouflage
Camouflage coloring works well and moves the character away from the more usual gaudy superhero costumes.

A strong look
The artist avoided the look of *The Incredibles* with a slightly more angular, muscular feel: "A strong look wins half the battle," says Clive.

Designing the kids

When starting to design the kids, the script brought to mind *The Munsters* and *The Addams Family* TV shows, so Clive allowed his mind to wander from that point.

He feels very strongly that characters who appear together must be easily distinguishable from each other. The trick here was to keep the characters identifiable while giving them all a family resemblance.

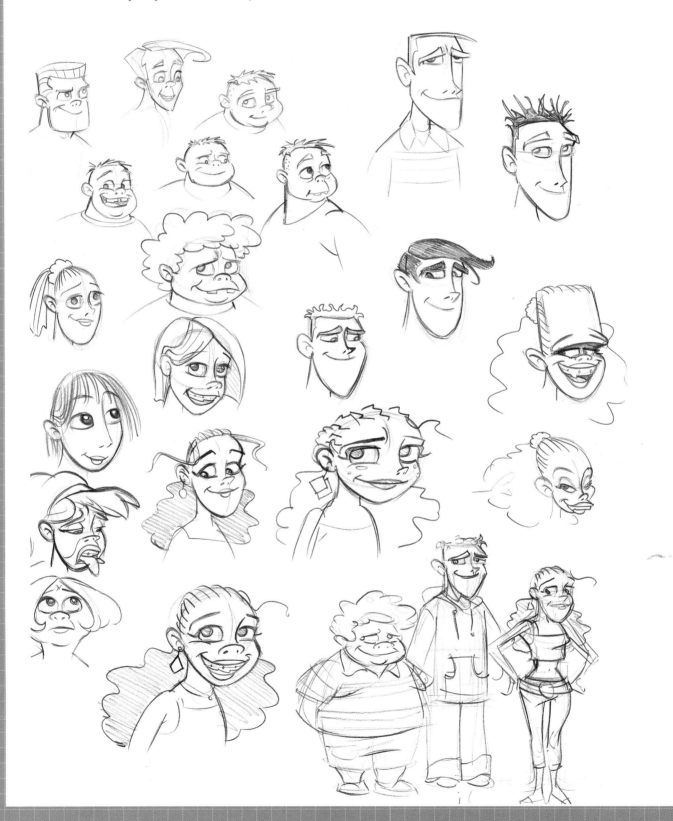

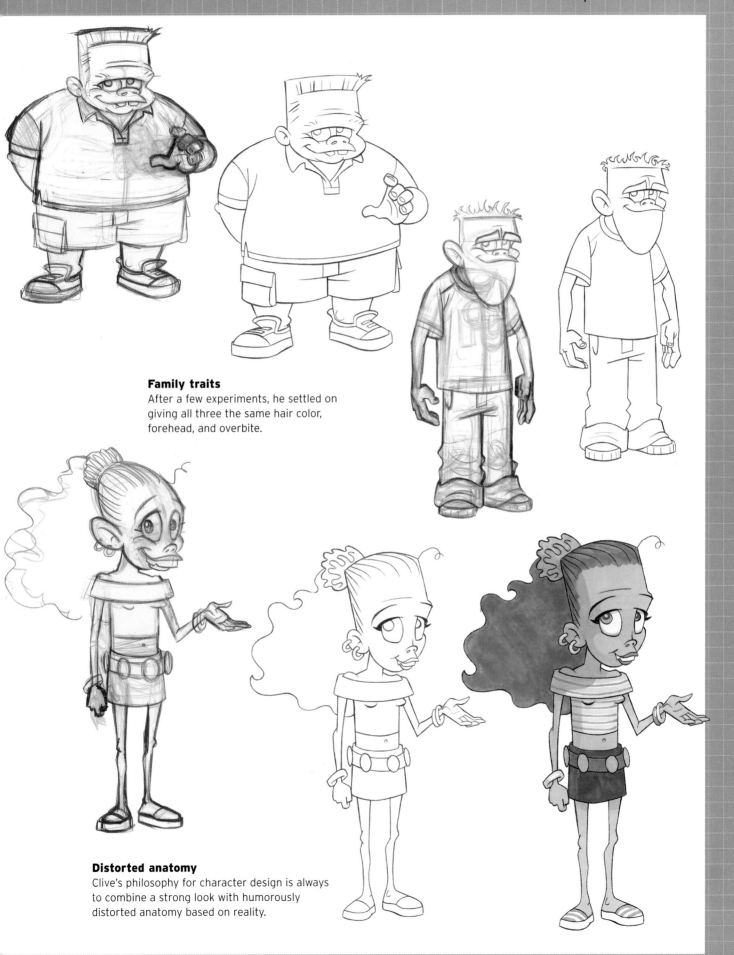

Family traits
After a few experiments, he settled on giving all three the same hair color, forehead, and overbite.

Distorted anatomy
Clive's philosophy for character design is always to combine a strong look with humorously distorted anatomy based on reality.

If you are determined to become a professional character designer, there will come a point when you must steel your nerves and submit your work to a potential employer. If you have been working conscientiously and steadily and finding the time to draw every day, you will find that, after just a few months, you should have an interesting and substantial choice of material.

Presenting Your Work

It really is worth getting the advice of more experienced artists, designers, or cartoonists in making selections for your portfolio. Find someone whose judgment you trust and ask them to select what they consider to be your 20 or 30 strongest pieces. From their selection you should make the final choice of between 10 and 20. At the start of your career, before you've had a chance to amass a body of professional work, a small number of high quality designs is a better option than a large number of mediocre ones.

If you are fortunate enough to get an interview, remember that the interviewer may not have the time to pore politely over every single design that you've ever made, especially if you are giving a running commentary on each drawing (which you shouldn't!).

You should aim to make the maximum impact in the briefest time, so take only your strongest work. You must learn to be self-critical and to know instinctively when a design is working and when it isn't. The final choice of what to include in your folio should always be yours, but try to tailor those choices to the needs of the potential employer. If they are looking for a designer who can draw cute kids, don't take along a selection of sword and sorcery characters just because you enjoyed drawing them.

Original art portfolio

Having selected your best work, display it in the best quality portfolio that you can afford—one with clear plastic inserts is best for this purpose. By all means take your original artwork to interviews or informal meetings with potential employers, but NEVER under any circumstances leave your originals with a third party; leave a CD or photocopies.

Photocopied samples

It really does pay to spend a little extra money on having your work professionally photocopied. If you are posting the copies but need them back, always include a self-addressed stamped envelope with your submission (and never forget to include your contact details).

CD folio

Many companies prefer to view a folio on a CD. If you can, get your work scanned and burned onto a CD. Nonetheless, it doesn't hurt to submit a few hard copies of your work to be kept on file.

E-mailing artwork

If you have access to a scanner and computer, e-mailing your artwork is the quickest way of getting it seen.

Web site

Most professionals have their own Web sites. Once you have taken the time and trouble to build and design one, it's a hassle-free way of allowing potential employers (and plagiarists!) the chance to see your work in a high-resolution, color format.

Resources

ADVANCED MARKER TECHNIQUES, Dick Powell and Patricia Monahan (Little, Brown 1994)

ANATOMY FOR THE ARTIST, Jeno Barcsay (Metrobooks 1993)

THE ANATOMY OF COSTUME, Robert Selbie (Crescent 1988)

THE ANIMATOR'S SURVIVAL KIT, Richard Williams (Faber & Faber 2002)

THE ART AND FLAIR OF MARY BLAIR, John Canemaker (Disney Editions 2003)

THE ART OF ANIMAL DRAWING, Ken Hultgren (Dover Publications 1993)

BATMAN: ANIMATED, Paul Dini & Chip Kidd (Harper Paperbacks 1999)

BEFORE THE ANIMATION BEGINS, John Canemaker (Disney Editions 1996)

BRIDGMAN'S COMPLETE GUIDE TO DRAWING FROM LIFE, George Bridgman (Sterling 2003)

CHILDRENS' BOOK ILLUSTRATION, Jill Bossert (Watson-Guptill Publications 1998)

CHUCK AMUCK, Chuck Jones (Farrar, Straus & Giroux 1999)

CLASSIC PIN-UPS, Jack Cole (Fantagraphics 2004)

COMICS AND SEQUENTIAL ART, Will Eisner (Poorhoouse Press 1985)

THE COMPLETE BOOK OF HUMOROUS ART, Bob Staake (North Light Books 1996)

THE DISNEY THAT NEVER WAS, Charles Solomon (Disney Editions 1995)

THE DISNEY VILLAIN, Ollie Johnston and Frank Thomas (Disney Editions 1993)

ENCYCLOPEDIA OF WALT DISNEY'S ANIMATED CHARACTERS, John Grant (Disney Editions 1998)

FACIAL EXPRESSIONS, Mark Simon (Watson-Guptill Publications 2005)

Glossary

ANTHROPOMORPHISM Endowing an animal or thing with human features or attributes.

BACKGROUND In 2-D animation, the setting or backdrop behind the animation (also known as B/G).

CALLIGRAPHY The art of fine handwriting (particularly in Chinese or Arabic script).

CARICATURE A humorous (drawn) representation that exaggerates features and character traits for comic effect.

CHINA MARKER PEN A wax- or grease-based pencil, originally intended for drawing on glass or china, but also used to draw directly onto acetate (cel) in animation.

CLEAN-UP The final, clean, line version of a rough drawing.

COMPARISON GUIDE A line-up of all the characters from a film or series showing their exact scale relative to one another.

CROSS-HATCHING Overlapping lines of any pattern that create varying degrees of tone and texture in a drawing.

DRY BRUSH Dragging an almost dry paintbrush over artwork to produce scumbled (softened) or textural brushstrokes.

EXPRESSION GUIDE Similar to a model sheet, but gives the range and expressiveness of a character's facial expressions.

FLOP To make a mirror image of an image or drawing.

FRESCO A watercolor painting made onto wet plasterwork on a wall or ceiling.

LEAD ANIMATOR In animated feature production, where the amount of screen time given to a character may be more than a single animator can cope with given the schedule, a team of animators will be assigned one character between them. The senior animator who determines the character's parameters of performance and movement is known as the lead animator.

LIGHT BOX In traditional animation, a drawing table with a backlight that enables an animator to see through several drawings simultaneously.

THE GLAMOUR GIRLS OF BILL WARD, Alex Chun
(Fantagraphics 2003)

HIRSCHFELD ON LINE, Al Hirschfeld
(Applause Books 2000)

THE ILLUSION OF LIFE, Frank Thomas and
Ollie Johnston (Disney Editions 1995)

MY LIFE IN PICTURES, Charles Chaplin
(Grosset & Dunlap 1975)

PAPER DREAMS, John Canemaker
(Disney Editions 1999)

PEN DRAWING AND PEN DRAUGHTSMEN,
Joseph Pennell (Kessinger Publishing 2004)

PICTOPLASMA, edited by Robert Klanten &
Michael Mischler (Die Gestalten Verlag 2001)

THE SECRETS OF PROFESSIONAL CARTOONING,
Ken Muse (Simon & Schuster 1980)

TEN EVER-LOVIN' BLUE EYED YEARS WITH POGO,
Walt Kelly (Simon & Schuster 1987)

TEX AVERY, Patrick Brion (Editions du Chêne 1984)

WEB SITES

awn.com (Animation World Network) Information,
job listings, tutorials, and all things animation.

characterdesign.blogspot.com Interviews with
top character designers and portfolios of
their work.

animationarchive.net Tim Montgomery's site. Model
sheets and clip art from Disney and Pixar films.

bobstaake.com Biographies of the best designers,
cartoonists, and illustrators of the last century.

LINE TEST The initial black-and-white pencil
animation shot in sequence and to length.

LIP SYNCH The movement of an animated
character's mouth in synch with prerecorded
dialogue to give the illusion of speech.

MODEL SHEET The main guide to drawing a
character's construction, attitudes, and gestures.

PEG HOLES The punched registration holes on
animation paper that correspond to and fit over
the peg bar.

PHONEME An individual sound component that
makes up human speech (e.g., the "uh" in "bugs").

ROUGH A free or gestural drawing that contains only
a little detail, and in which line quality and
"cleanness" is not emphasized.

SELF-TRACE Any outline color that is the same as
the fill color.

STORYBOARD A pre-production sequence of
drawings in panel form that shows the most
important acting and action aspects of a film.

TABBING Sealing off the outer lines of an area of
color on a character by making them connect.

THUMBNAIL A tiny, loose, "thinking" or
planning drawing.

TURNAROUND A series of drawings depicting a
character as seen from (usually) five angles.

VANISHING POINT The point in perspective at which
any two converging lines will meet.

ACKNOWLEDGMENT

A round of applause to all the following for their support, kindness, and inspiration: Halina Bowen, Freddy the Cat, Dan Docherty, everyone at Cartoon Network, Ottilie Godfrey, Kate Kirby and Julie Joubinaux at Quarto, Rob McCarney, Clare Morris, Iona Paterson, Tom Robinson, Mandi Stephens, Marion Urch, and Ray White.

And many thanks to Clive Pallant, Teddy Hall, and Phil Vallentin for their rather spiffy contributions to this book.

Index

CREDITS

Quarto would like to thank and acknowledge the following:

Key: a = above, b = below, l = left, r = right

p8 The Art Archive / Marc Charmet
p9a Alice's Adventures in Wonderland by Lewis Carroll; illustrated by
John Tenniel; Dover Publications Inc.
Quarto would also like to thank Randall Sly at The Character Design
Blogspot http://characterdesign.blogspot.com and the following artists:

p125bl Cedric Hohnstadt www.cedricstudio.com
http://cedric-hohnstadt-intervew.blogspot.com
p125br Sumeet Surve
http://sumeet-surve-interview.blogspot.com

All other images are the copyright of Quarto Publishing plc. While every
effort has been made to credit contributors, Quarto would like to apologize
should there have been any omissions or errors—and would be pleased to
make the appropriate correction for future editions of the book.